B/S

BIS Publishers
Building Het Sieraad
Postjesweg 1
1057 DT Amsterdam
The Netherlands
T (31) 020 515 02 30
F (31) 020 515 02 39
bis@bispublishers.nl
www.bispublishers.nl

ISBN 978-90-6369-302-2

Second printing 2014

Contents

Preface 006

1. Introduction 008

2. What, why, when 014

2.1 It all began with waterfall 018
2.2 What is Agile? 018
2.3 What is Scrum? 020
2.4 When to Scrum 022
2.5 When not to Scrum 024

3. How to set up a project 028

3.1 A project is made up of sprints 032
3.2 Sprint setup 034
3.3 Flexible scope 037
3.4 How many sprints do you need? 038
3.5 Building a Scrum team 039
3.6 One room for all 043
3.7 Pigs and chickens 044

4. Sprint 0 046

4.1 Strategic intake & research 050
4.2 Product statement 052
4.3 Design Concept 055
4.4 Technical solution outline 057
4.5 Product backlog 057
4.6 Definition of Done 064
4.7 Sprint 1: scope estimate 064
4.8 Sprint goal 065
4.9 Practical agreements 067
4.10 Setting up the Scrum room 067
4.11 Phew! 083

5. Go sprint! 084

5.1 Sprint planning 088
5.2 Daily standup 095
5.3 Daily reviews 096
5.4 Backlog grooming 099
5.5 Sprint demo 102
5.6 Retrospective 107
5.7 Final retrospective 108

6. Sprinting secrets 110

6.1 Integrating UX and development 114
6.2 Advanced deliverables 122
6.3 Quality is flexible, honest! 124
6.4 Maintaining creativity 124
6.5 Integrating user centered
 design (UCD) 125
6.6 Documentation 126
6.7 Dealing with clients 128
6.8 Dealing with the agency 130

7. Troubleshooting 132

7.1 People 136
7.2 Process 138
7.3 Product 142

8. Meet the team 144

 Scrum Master 148
 Scrum Master 150
 Product Owner 152
 Strategist 154
 Interaction designer 156
 Visual designer 158
 Web developer 160
 Project manager 162

Glossary 164

When we established Fabrique in 1992, we had been freshly trained at the TU Delft in design methods where we worked step by step from a design brief towards a product. This was a serial approach which we nowadays call the waterfall method: a method that provides a guideline and guarantees results, especially in static and straightforward situations.

In the course of the years, there have been many changes in our work environment. The dynamics in developing digital media, in particular, have increased to a point where a classical approach will no longer do. For one thing, our customers are asking for shorter lead times. Moreover, they increasingly have pertinent expertise themselves, and it is therefore very useful and desirable for them to actively participate instead of just placing an order. On a regular basis, projects are too large for controlled development and documentation, while at the same time keeping up the pace, with conventional methods. And our customers are not only demanding the final result; they also want influence on the journey towards the goal. On top of all that, we are working in a multidisciplinary environment where strategists, interaction and visual designers, copywriters and programmers want to work together. Therefore, it was time to think about a new approach.

In 2008, we got started on Scrum. Through trial and error, we found out that this method offers a very good response to the changing demand in our design practice as well. Since 2008, at Fabrique, through experimentation, evaluation and fine-tuning we expanded the Scrum method from a software development tool to an integral innovation method in the field of digital media. All this time we were driven by our — admittedly somewhat geeky fascination for the design process.

So, is Scrum the Holy Grail of digital media development? Of course not. Scrum bears certain risks, and the decision to use it must be carefully considered. This aspect is covered in-depth in the book as well.

A book?

Yes, a book. Scrum is a very physical method. You cannot miss it if people are scrumming somewhere: there will be post-its and flip-over sheets all over the place. Therefore, we found it very appropriate to bundle all of our knowledge and experience in an old-fashioned book — another physical object that you can soon have lying about in your Scrum rooms.

We wish you success!

Gert Hans Berghuis
Managing Partner, Fabrique

By Gert Hans Berghuis

Fabrique, a multidisciplinary agency, has scrummed for 48 national and international clients since 2008. Our Scrum experience consists of numerous projects for a wide range of industries such as finance, retail, fashion, education, and transport. With 76 Scrum Masters, designers, developers, copywriters, directors and strategists, we scrummed for 56,619 hours, together with product owners, photographers, content managers, technical partners, and stakeholders, in 264 sprints. In that time, we completed 2,361 stories with a total of 30,710 tasks. 30,711... 30,712... 30,713... and counting...

By Pieter Jongerius

1

Intro duction

ppen,

chrijven

lcots,

rümako

11

VO

Slideshow

Slideshow
(of zoiets)
gedrag
afspreken

HTML/CSS
JS achter
slideshow
(of zoiets)

GALLERY FULLSCREEN

BUTTONS
NEXT
SWIPE
...
TRANSPORTS VOOR (IETS / longet

Agile design & development, and Scrum, mean the return of common sense. In Agile, future quality is more important than past decisions. Trust is more important than documentation. Freedom in exchange for commitment.

With Scrum, you as the design & development team invite the client into your territory. Together you will develop the insights and products which will help his business grow. You will be open to his ideas and you will be required to expose many different facets of yourself. Together you will overcome disappointments and celebrate victories. Selling Scrum is selling an experience. Scrum is never boring!

Due to the set rules in Scrum projects, dilemmas come to light at top speed: break off or give a bit more time? Discuss now or let things simmer? Dig into it or make assumptions? This requires the very best from teams. In this book the main steps and issues are discussed, and team members tell us about their experience:

2. What, Why, When - This chapter discusses the history and philosophy of Scrum, the reasons for applying it, but also possible reasons why not to use Scrum.

3. How to set up a project - If you've decided to scrum, you will want to know what the team has to look like, how much time it costs, what the structure of Scrum projects is and what the requirements are in terms of organization and facilities.

4. Sprint 0 - This first special stage provides base and defines direction. How do you get to grips with the as-signment? How do you get the right ambition in the team? The team will start ideation, do basic design and set up technical architecture. It will divide the project into manageable chunks.

5. Go sprint! - This is the real deal. Kick-offs, progress monitoring, evaluations and more. This chapter focuses on the daily practice of the Scrum.

6. Sprinting Secrets - Now that the basics of Scrum are covered, we can elaborate on some of our real secrets: how can you simultaneously design and develop? How do you maintain or enhance your creativity? How do you deal with difficult product owners?

7. Troubleshooting - Like in any good handbook there is a problem solving section. The most common problems are briefly described and we offer possible solutions.

8. Meet the Team - Eight team members from different disciplines (director, interaction designer, visual designer, developer, Scrum Master, project manager, client) each answer important questions about their role, how Scrum has helped them, about the dangers, etc. We offer links to five minute video interviews online.

9. Glossary - Yes, Scrum uses a lot of slang terms. Here are the most important ones.

Scrum is one of the most difficult processes to master. It all comes down to the ability to improvise, craftmanship, and authentic hard-won team building (so not the semi-survival blindfolded paintball-on-a-ledge surrogate teambuilding that you can buy just anywhere).Take this handbook with you wherever you scrum, you will need it!

In the next chapter we will start with the first step: deciding whether to use Scrum or not.

By Pieter Jongerius

2

What,
Why,
When

Everyone has different reasons for wanting to scrum. Maybe your project turnaround times seem too long. Maybe you are fed up with unworkable specifications—or maybe you'd just like to work with post-its a bit more.

There are many different reasons why teams and organizations want to Scrum. There are also situations, however, in which Scrum won't work. This chapter looks at the main ones.

2.1 It all began with waterfall

In waterfall, various disciplines act step by step like a kind of relay race: strategy, interaction design, visual design and development. We worked with the waterfall model for many years and sometimes still do.

For many projects, however, the step-by-step process is problematic. That's because in practice, the aims and functionality you wish to achieve are influenced by things that may only become apparent once the project is underway. Some things occur due to the nature of the work: a developer realizes that a certain interaction is very tricky to build; or an editor notices that the design doesn't quite meet communication requirements.

It is also just as common for part of the assignment to change. New business rules may crop up. Company strategy may be altered. Some of the designated photographs may prove to be unsuitable.

In waterfall, this progressive insight leads to delays due to the reviewing and reworking of previous deliverables, such as requirements, flows, and annotated wireframes. Scrum eliminates all this by enabling disciplines to interact right from the start; by leaving room for new insights; and, by eliminating intermediate deliverables as much as possible.

"The Waiting Developer"

2.2 What is Agile?

The terms Agile and Scrum have mainly been used to refer to software development methods. In 2008, however, we discovered that the Agile approach, with Scrum as a method, is not only suitable for software development. It is also extremely suitable for improving the entire process of concept, design, and development. As one of the pioneers of this approach, we are delighted to see more and more people embrace this idea.

When using Agile methods, accommodating change is more important than following a strict plan.

Agile is a way of thinking. Scrum is a method that was developed in line with this way of thinking. Agile came about in the seventies as a group of "adaptive software development" methods. It gained wide recognition in the nineties under the name "lightweight methods".
Since 2001 these methods have become known as "Agile methods", after the groundbreaking *Manifesto for Agile Software Development*, which was published that year.

Drawn up by a group of visionary software developers, this manifesto is brief enough to include here:

We are uncovering better ways to develop software by doing it and helping others to do it. Through this work we have come to value:

> Individuals and interactions
> *over processes and tools*
> Working software
> *over comprehensive documentation*
> Customer collaboration
> *over contract negotiation*
> Responding to change
> *over following a plan.*

While the *italic* items of this list carry value, we value the bold items more.

A great deal has been said and written about the principles on which Agile methods should be based. We recommend that you decide for yourself which ones work best for you.

Our own selection—also listed on the inside cover of this book—are as follows:

End users first
Scrum is not about the team. It is not about the client. It is not even about the product. It is about being relevant to the end-users.

Freedom vs. commitment
Scrum offers freedom in exchange for commitment. This goes for the organization, the team members, and the client. Welcome change—but also, kill the monster while it's small.

Eliminate waste
Direct and ad-hoc communication replaces the costly overhead of time spent on meetings, documentation, and re-workings. Prioritization eliminates the incorporation of waste into the product itself.

Self-propelled team
No. A team doesn't actually have to manage and organize itself—as long as it's open, energetic, and self-motivated, and you don't have to drag it around wherever it needs to go.

19

Timebox everything
As in real life, we always want more, and we can't always have it. Timeboxing prevents us from dwelling in dreams: the clock ticks, and the team moves on.

Shippable product
Any Sprint result should be a product or product part that's ready-to-deploy—with no fake copy, no blocking issues, no black boxes or white spaces.

[Adapted from AgileManifesto.org, Lean Software Development (Poppendieck 2003) and Bruce Lee.]

2.3 What is Scrum?

One of the abovementioned *lightweight methods* was Scrum. At first tentatively referred to as the "rugby" approach, Scrum developed into a well-defined method in the early 1990s, due to the collaboration of people such as Ken Schwaber and Jeff Sutherland.

The principles of Agile apply to Scrum. Scrum dissolves boundaries and distributes responsibilities, which, in waterfall, are protected. A radically different way of working, Scrum has as many activities as possible taking place simultaneously in one room. It focuses on efficiently preparing product components for publication, going from first sketch to implementation in blocks of time lasting several weeks.

A few smart rules ensure that this process is not only fast, but also quite controlled.

The basic concept behind Scrum is that your activities are based on a fixed overall vision, rather than fixed goals and content. Because the environment is constantly changing, Scrum does not posit a detailed "master plan", allowing final results to come about organically. This way, you avoid ending up with a final product that—while meeting earlier specifications—unfortunately no longer meets the end users' actual needs.

In 2008 we applied Scrum to our overall design and development process—adding, most importantly, a multi-disciplinary component. This allows for many disciplines to be applied to the same project at once. With, for instance, UX designers, visual designers, developers, and editors working together, Scrum ensures this process remains clear and efficient.

We owe many thanks to Henrik Kniberg and his fantastic, downloadable book, *Scrum & XP from the Trenches*.

fabrique.nl/getagile/trenches

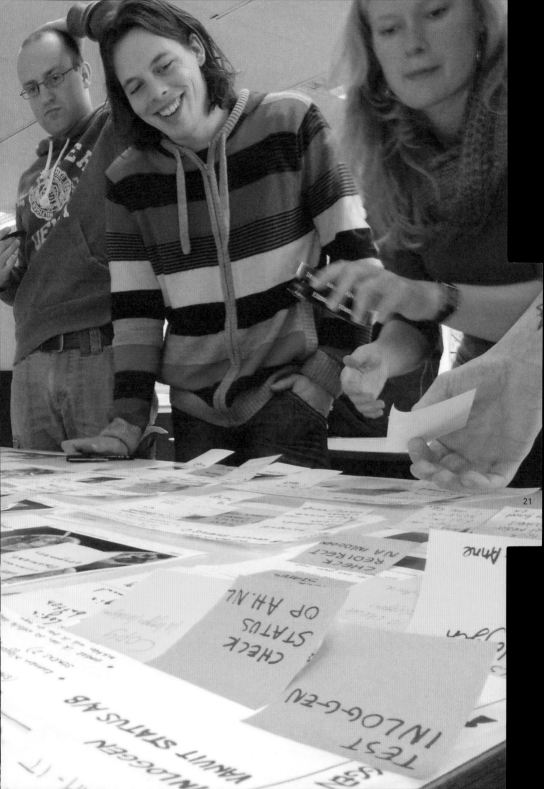

2.4 When to Scrum

Advantages for the client

It is actually quite strange that agencies often settle for relatively little customer contact when designing and developing a complicated project. On waterfall projects in particular, an entire team often gets to work on the basis of a handful of documents and a briefing session lasting merely a few hours.

Scrum, however, has the client play an important role. The direct client, the *product owner* is at the core of the team and has the important responsibility of guiding the team and making decisions. To this end, he or she works with the team several days a week in the team room.

Scrum lets you see just how useful it is to take ongoing advantage of your client's customer and market knowledge. And as a nice bonus: there's no more need for those awful foam-board presentations—have we hit the mark yet?—that are so often just a shot in the dark.

This great change in the distance between agency and client is something everyone has to get used to, but the impact is huge.

Scrum offers clients three significant advantages:

◆ Short time to market—Scrum is fast. In our experience, turnaround times are about half those achieved with waterfall.
◆ Quality—Scrum encourages a feeling of responsibility for all people involved and improves communication among disciplines. Thus the team becomes much more motivated, and big surprises are prevented. Scrum also allows for far more control over the final result. This all has a marvelous effect on the final quality of the agreed deliverables.
◆ Delivery assurance—Progress monitoring and evaluation are deeply embedded in the Scrum process. Therefore a Scrum team is able to guarantee that a product will be ready within a limited, short timeframe.

Scrum is useful…

◆ If your projects require a lot of reworking: When progressive insight occurs only in later phases, reworking becomes necessary. By bringing these phases much closer together, progressive insight is gained much earlier. The loops become shorter, and there is less loss.
◆ If projects often run over: There are hundreds of reasons why waterfall projects may run over. But most common ones are insufficient progress monitoring, paired with a limited learning

capacity built into project organization. Scrum deals rigorously with both.

◆ If the different disciplines do not understand and/or blame one another: Putting everyone in a single room means that people really have to work with one another. Less physical distance automatically leads to less mental distance. We're in this together!

◆ If designers design things that are difficult to build: We have all heard of artists who don't want to make allowances. And while the magic of design is an important part of the creative process, at some point we all have to come back down to earth. Scrum (ultimately) makes this happen.

◆ If developers encounter problems implementing the delivered design: There may be many reasons for this. The design may be too outrageous. The scope or quality of the design may be insufficient. The technical or functional preconditions may be unclear. But the solution is often the same: bring people together and thus improve communication.

◆ If people in your organization slow projects down by constantly having their say: Scrum provides focus. Those who are not part of the process realize that it's all systems go—for real. And this requires a certain level of autonomy. There's no stopping the Scrum train!

> Try to keep predictions to A minimum. Scrum thrives on open-mindedness & common sense.

Scrum provides...

◆ A foundation for your product: With the client as part of the team, you have a greater amount of useful information to base your work on. It is all about the "bandwidth".

◆ Adaptability: With the project not entirely fixed in advance, and with an inspection and control system in place, you can make better use of ongoing progressive insight—regardless of

2 What, Why, When

whether this insight comes from the client or another member of the team.

◆ Visibility: Scrum makes your process, people, and motivation very transparent. Any pleasant surprises? They can be celebrated with your client. Any disappointments? Then you and your client can get through those together—and enhance your mutual understanding in the process.

2.5 When not to Scrum

When Scrum works well, it releases you from much of the overhead you may be used to with waterfall projects. This makes for a most enjoyable process, whereby common sense, craftsmanship and passion for content can surface. Commitment will be rewarded.

Nevertheless, Scrum is not for everyone. In some environments and for certain clients, Scrum is too fast, too isolating, or too centered on informal collaboration. Even in these situations, Scrum needn't be dismissed entirely. Setting up a Scrum board (see page 69), for example, is always a good way to get an overall picture. It all comes down to your organization's ability to implement the method for their particular purposes.

Scrum is not useful...

◆ If your project requires a lot of thinking and realization: Scrum is speedy and aimed at "getting things done". Depending on the task or the person, Scrum can be too speedy. It's virtually impossible to let an idea simmer for a week or so, and then go back to it. But it is always possible to find room for brainstorming, ideation, radical concepts, and sparkling innovation.

◆ If the quality or seniority of team members is below par: Scrum is all about improvising, prioritizing, and making choices. It takes quality and experience to do all of this efficiently.

◆ If the client has difficulty making decisions: In waterfall, a client who hesitates causes delays. Parts of the product, for instance, may not be approved. In Scrum this would lead to an uncontrolled process, whereby all kinds of things get done—but none of them would be based on correct decisions. A good Scrum team will spot this and not irrationally carry on sprinting.

◆ If a client's democratic sign-off policy cannot be breached: If clients are extremely democratic or have unclear decision making structures, there is a chance that the client's team representative, or product owner, will receive insufficient mandates. When every little detail has to be discussed with the back office, the sprint soon slows down.

◆ If the client or supplier has a very for-
mal culture: When team members are
tied to extensive documentation or 'Def'
deliverables between disciplines, it is
at the expense of the parallel nature of
sprints. The ability to continue working
on semi-finished products, premises,
and presumptions is what makes
Scrum so efficient.

So…

Now you know how Scrum came about,
what its advantages are, and how we have
adapted it for the design & development
world. If you decide to start Scrumming,
move on to the next chapter: How to set up
a project.

Happy Scrumming!

Decided not to
Scrum a project?

Using a scrumboard
might still be a
good idea to do
your planning.

27

By Anna Offermans

3

How to set up a project

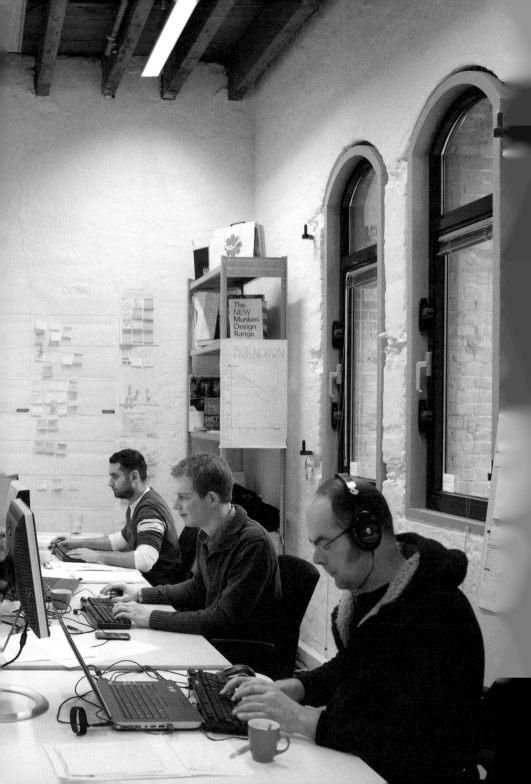

3.1 A project is made up of sprints

This book refers mainly to interactive media projects. These projects have an identifiable, often strategic beginning. And being within the interactive media domain, they are multidisciplinary in nature, with a variety of different roles required to accomplish the product.

A project must do a number of sprints before it can go live. A sprint is a unit of several weeks, during which a portion of the project is carried out. Sprints can also be used when a project is already live, in order to make step-by-step improvements to the product. In the world of Scrum, they are then often no longer referred to as sprints, but "iterations".

The entire project is divided into "user stories". A story is an identifiable, more or less independent unit. For example; "as a user, I want to be surprised with new recipes". The collection of all the stories relating to the project as a whole is called the "product backlog", the list of things we want to realize. During a sprint, several different stories are realized; the number depends on the size of the stories. Sprints have tight deadlines, ambitious goals, and last two to three weeks. Running over is not an option. Adjustments however, are allowed to be made.

More about these topics in the following chapters. See the illustration below:

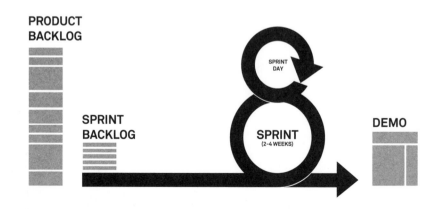

3.2 Sprint setup

So a project is divided into sprints. But what do these sprints look like? This is determined in the "sprint setup". The sprint setup is, to a large extent, what determines the success of a project.

Fixed deliverable sprints: yes or no?

An important decision that must be made when starting up a project is whether the sprints will each have their own "deliverable" or if they will collectively deliver the final product. In most cases, the stories are simply divided over the sprints in a deliberate order. But sometimes it is more useful for each sprint to develop an appointed portion of the project. This ensures proper focus on the topic during the sprint, and strict timeboxing for the various components. The big disadvantage is that—in the event of progressive insight—you are not allowed to give more attention to a particular project section at the expense of another.

Combining design & development

In principle, we design and develop our products as one single Scrum team. This team can be made up of members from different organizations, such as ourselves, the customer, a development partner, etc.

Certain circumstances, however, may push us into alternative decisions. For example, we may find ourselves collaborating with a development partner who is unable to sprint with us. We must then involve them in our activities on a remote basis, as much as is feasible. We might do this by having the developer participate in Sprint 0, backlog grooming and possibly sprint planning meetings. Even in this type of situation, Scrum is a powerful tool for accomplishing good projects.

We use this method for some of our e-commerce projects. We first integrate strategy, design, and front-end development into the Scrum. Parallel to this, back-end logic such as system links, data models, and stock management might be handled remotely.

If you have the chance to genuinely include development, however, seize this opportunity! We now respectfully call a Scrum operation that incorporates all its related disciplines an "*überScrum*"—and we carry out most of our projects this way. This might for example be a website or an app with a CMS and workflow logic for customer contact. The Holy Grail of Agile design & development is to do design, front-end development and back-end development simultaneously in one room. But it's not an easy feat to do this properly.

(For more about this, go to Chapter 6: "Sprinting Secrets".)

What does a sprint look like?

A sprint is a portion of a project, a unit lasting several weeks. But what does a sprint look like in terms of planning? Over the years we have developed a few rules of thumb:

◆ A project has a fixed sprinting pattern. The number of days and the specific days each week are always the same. Demos and usability tests are planned in advance.

◆ There are usually three or four sprint days per week. This allows for other activities and part-time work. For many customers, this is also a comfortable pace. If top speed is required, there is the option of five sprint days per week— which is pretty tough for the team as well as the client, but can certainly be worth it! On the other hand, scheduling a mere two sprint days per week is not advised. The team doesn't manage to get up to speed and must constantly get back into the status of the project.

◆ It's a good idea to match your Scrum week with the calendar week. So, start a sprint on Monday and do the demo on Friday (or Thursday, or Wednesday). This is the best way to get that feeling of really ending a sprint in one week, and starting fresh with a new one the next week.

◆ A sprint usually lasts two weeks. This pace ensures fast enough feedback from demos and the retrospective. In the

Are you about to start Scrumming in a design & development environment? If you decide to go straight to überScrum, start with a small project, using your smartest or most experienced people.

event of longer projects (three months or longer), you could opt for a three-week sprint. Three weeks may also be better for überScrums that are developing innovative products. This gives the team more time to iterate within the sprint.

◆ Sprint 0 may differ from the other sprints in terms of scope and planning. The estimated time for this sprint is that, per team member, there are as many *days* as there are *sprints* in the project. Does the project last for five

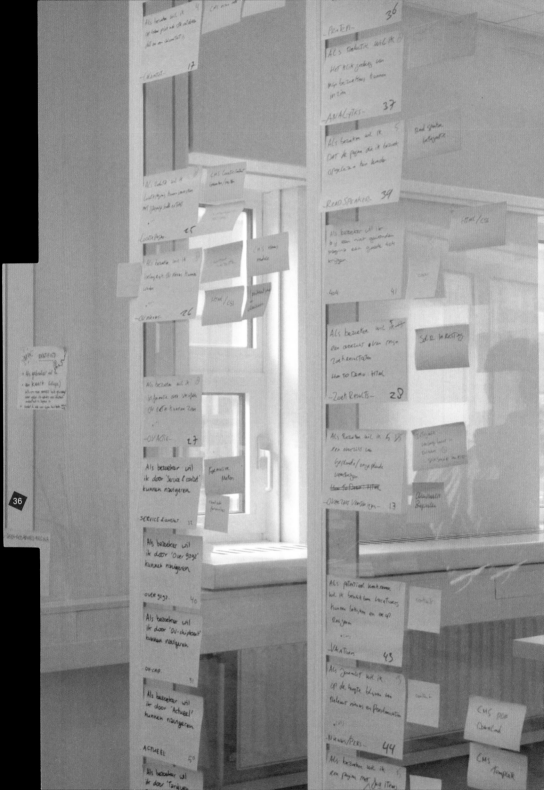

sprints? If so, Sprint 0 lasts five days, spread over two weeks. In Sprint 0 you may decide to allocate more time to the discipline *leads* than to the juniors.

◆ Contrary to popular belief, the entire Scrum team does not have to be working on the project on all of the Scrum days. Often, development requires more workdays than design. You may decide to have four or five days of development, and three or four days of design. Do try to have the team seated together, even on days when designers may be working on other projects.

3.3 Flexible scope

Be like water: In Scrum your agency is constantly being exposed to all kinds of influences: your client's whims, ever-changing requirements and demands, and pleasant and unpleasant surprises across the board. Don't try to foresee them—but accept them and deal with them in an intelligent and flexible manner, thus optimizing the product.

As Scrum must lead to a final result within a set timeframe (a certain number of sprints), the *Be like water* principle has an important effect:

 The scope is flexible—

For many clients this takes a lot of getting used to. The design & development team

In our experience, Scrum projects are not more or less expensive than waterfall projects. So when drawing up your budget you can just start by using your usual estimation method.

does not promise there will be 138 features; it promises a product that will meet the client's vision and goals. It keeps track of this progress on a day-to-day basis, and the feedback loops are very short.

In exchange for commitment, the team gets freedom. This freedom is not unconditional: in exchange for flexible scope, the team grants all power over the product backlog to the product owner.
To put pressure on the project, the team

37

offers ideas and inspiration for a higher level of functionality than actually fits the project. At the same time, it protects the quality of each component delivered. It is up to the product owner to set priorities on a continuous basis.

3.4 How many sprints do you need?

Before the project commences you would like to make a rough estimate of the costs, and thus the number of sprints. Like in waterfall, you can determine the total number of sprints by estimating the amount of time required to develop a Minimal Viable Product (MVP), on the grounds of the preliminary questions or specifications provided by the client.

MVP implies that the product must work extremely well and meet the customer's main goals, and, as such, be a finished entity. But don't go straight for the most complete, cool product. After the initial release, you will have enough time to make improvements.

A new project

A new project is made up of at least three sprints, preceded by a Sprint 0. The main reason is that a team needs some time to get started, to get to know one another,

and find the optimum way of collaboration. Furthermore, the Scrum steering mechanisms need a sprint in order to truly become efficient.

If, when drawing up your budget, you estimate that a Minimal Viable Product can be achieved in much less time than a Sprint 0 plus 3 sprints, it is probably best not to stick to the Scrum method.

Ongoing development of an existing product

As previously mentioned, Scrum can also be used to improve products on an ongoing basis. In this case Sprints are usually called "iterations". In each iteration, a fixed team delivers a new product release. In practice we also make use of a hybrid: the improvement of an existing product, carried out by the same team. If this is done using Scrum, we maintain a minimum of 2 sprints. It is not usually worth rigging up a Scrum room for just 1 sprint.

It all becomes clear in Sprint 0

In Sprint 0 the *product backlog* is defined and roughly estimated. The team provides a broad estimate of the size of certain stories by allocating points. This will give you a good idea of what the team's progress with the product backlog will be after, for example, 3 or 4 sprints.

3.5 Building a Scrum team

Scrum teams are multidisciplinary teams. In particular if the method is used for design projects, there will be a number of people who have different disciplines and different characters sitting together in one room—people who may not be used to working together so closely. This requires their full cooperation and an awareness of their common goal.

Typical Scrum roles

In a Scrum project there are various roles, which waterfall projects do not have.

The Scrum Master
The role of the Scrum Master is that of a facilitator and motivator. He or she ensures that Scrum elements such as the "daily standup" and "retrospective" take place at the correct time, and with no obstacles that could interfere with anyone else's activities. And there could be all kinds of obstacles. Often they concern project related challenges, such as differences of opinion within the team, or team members having difficulty progressing. But the Scrum Master also deals with other obstacles: a project server that is down, a team member who's off sick, or even noise pollution or any other external distracting influence.

The Scrum Master looks after the team. The Scrum Master is also expected to motivate the team, improve collaboration, spot and discuss any difficulties, and ensure that a positive atmosphere is upheld.

> A one week interval, or pause, may be incorporated into projects lasting more than 6 sprints.
>
> This lets everyone catch their breath and take in what has been done so far-after which you can start sprinting again, fully refreshed!

Any team member can become Scrum Master, as long as they have an interest in and generic understanding of all the disciplines involved. In our case it is often an interaction designer, but we also see developers, visual designers and project managers take on this role. Depending on team size and project complexity, the role of the Scrum Master can be combined with exercising your own profession.

By Anna Offermans

The product owner (PO)

The product owner, or PO, is the person who owns the product on behalf of the client and who represents the client in the team. He or she manages the product backlog and decides what the priorities are. This is done by discussing matters with colleagues and by getting advice from the Scrum team. The PO also writes the stories, along with the Scrum Master. It is essential for the PO to be with the team on the sprint days, to answer questions and make decisions straightaway. This is necessary in order to progress. It is very important that this person has sufficient mandate from his or her own organization.

The stakeholder

Stakeholders are all the interested parties in this project. They are usually a range of different people who are involved on behalf of the client; but they could also be, for example, end users who are involved through usability tests. At the end of each sprint the stakeholders are invited to see its outcome in the so-called "demo". Afterwards, they can share their findings with one another and, above all, pass them on to the PO. The PO can then decide whether, for example, changes or additions should be tacked onto the product backlog as new stories and, if so, where.

The Scrum team

The Scrum team is the team that will carry out the work and be fully committed to the

You will only find out how much work is required for the Minimal Viable Product by the end of Sprint Ø. And so this is a good time to take another good look at your initial budget.

41

sprint goals, which are set at the start of each sprint. As a rule the Scrum team is made up of:

- ◆ visual designers
- ◆ interaction designers
- ◆ front-end developers
- ◆ back-end developers
- ◆ tester
- ◆ copywriters
- ◆ Scrum Master
- ◆ product owner (PO)

These are the people who are on the team and who, in principle, work on the project on all of the previously set Scrum days. Besides these permanent team members, there are also a number of people who collaborate at set times: for example, an art director who carries out reviews with the designers on a regular basis; or a strategist who makes sure the project lives up to expectations. They are not part of the team because they proportionally dedicate much less time to the project.

The project manager has mainly a supporting role. If this person is not the Scrum Master, he or she assists the Scrum Master with matters such as team changes, sprint planning, and financial issues.

Balancing the team's senior / junior staff

Scrum has more senior workers on a team than waterfall does. There are several reasons for this:

◆ In Scrum, the various components of the product are dealt with one by one, from the first sketch up to implementation. As soon as one component is completed, the next one is dealt with. One risk of this approach is the loss of the full overview. This is one reason it is so important to have senior staff members on the team: to maintain the overview and a proper grasp of the consequences following decisions.

◆ Another risk is that creativity and experimentation are not granted enough space. It is essential to show the client that it is sometimes vital to maintain this space. After all, it will improve the end product!

◆ It is also essential for the different disciplines to be at an advanced level, because it is expected that members of a Scrum team have the ability to confer with the other disciplines and understand difficulties and problems outside their own area of expertise.

◆ Lastly, past experience shows that senior staff members are more adept at finding solutions for all kinds of tricky situations, such as changes in the PO's requirements, or unexpected challenges arising in the design or building process.

Junior team members are, of course, also very valuable. And this methodology ensures that there is a high level of stability, and that everyone is able to focus on a task at the same time. Furthermore, the method's open and multidisciplinary nature ensures that juniors soon learn all the tricks of the trade and become familiar with all related specialities.

Our rule of thumb: there must be at least one senior staff member per discipline in a team.

3.6 One room for all

Scrum thrives on *ad hoc* communication between team members. This is why the whole team works together in one room—at all times. Just one door between two team members will drastically reduce the communication bandwidth between them!

Past experience shows that it's best to mix up the different disciplines in one room. Put that introverted developer next to the extroverted designer. Sit the new team member next to people who have known each other for years. It takes some getting used to, but it pays off and encourages collaboration. Another thing that takes getting used to is the fact that the team is in the same room as the client:

◆ On the one hand, it is very practical for the client to sit together with the team. Discussions can take place straightaway, decisions can be made quickly, and one gains insight into and understanding of other people's activities. On the other hand, designers might find it extremely tiresome to have clients constantly looking over their shoulders and expressing their opinion every time you move a pixel. Try to explain that as a designer you need room to experiment, and pinpoint certain times throughout the day when the client is allowed to take a look or even shadow you.

During the sprints, let the editor produce realistic content, which will be entered into the CMS. This will also test whether the CMS is comprehensible and easy to use.

◆ At times it may also be better if internal design reviews with the art director take place in a different area, away from the client. A design team sometimes just needs some space to discuss things openly with each other. So make sure you get this space!

◆ If the client has other people on the team—for example, not only the PO but also an editor, and/or one or more developers—the same thing applies to them. Ensure that there is room to

discuss matters with each other away from the team, and try to ensure that the team doesn't get contradicting information from various people. The PO has the last word.

More on the Scrum room in the next chapter.

3.7 Pigs and chickens

The different roles are often divided into two groups, pigs and chickens, named after the chicken and pig fable. In this fable the chicken suggests to the pig that they open a restaurant together called "Ham and Eggs". The pig replies that he doesn't think this is such a great idea. After all, he would have to fully commit and literally sacrifice himself, i.e. be slaughtered, whereas the chicken merely has to contribute an egg.

For us, the "pigs" are the Scrum team members and the PO. They are fully committed to the project and to the Sprint goals, and are accountable for the results. The "chickens" are those who consult on the project and are kept informed of its progress—they are the stakeholders.

Has the sprint setup been determined? Post-its bought? Your people are at the ready and you've stocked up on coffee? Then it's time to get started!

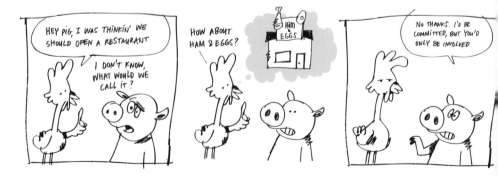

[adapted from: www.implementingScrum.com]

By Anton Vanhoucke

4

Sprint 0

So you've got everyone on board and have decided to Scrum! Sprint 0 is where you get down to it. Imagine your Scrum team as a unit of highly trained commandos standing around a map in a low-lit field HQ.

At Sprint 0, the team determines the strategy and everyone synchs their watches. They focus on prep-work, like packing the right equipment and deciding which are the right steps to take in order to reach their goal. The discussion and shared understanding of these steps is key here. Yes, the main deliverable of Sprint 0 is the product backlog—but the backlog is no more than the minutes of a meeting about stories.

From this point on, team members should have read up on Scrum. But, hey, they probably won't have if they're like most busy people involved in websites. Now might be a good time to explain the basics of Scrum to them.

The point of Sprint 0 is to do the groundwork that will allow you to go full speed ahead with development in the next sprints. To do this, you must establish your focus. Sprint 0 ensures there is a clear vision and team support for the development strategy, and for the next sprints, whereby you will focus on tactics. The Sprint 0 groundwork consists of:

Content related elements:

◆ Strategic intake & research
◆ Product statement
◆ Design concept
◆ Technical solution outline

◆ Product backlog
◆ Definition of Done
◆ Sprint 1 scope estimate
◆ Sprint goal

Process oriented elements:

◆ Practical agreements
◆ Setting up the Scrum room

Unless your project requires a large amount of groundwork, Sprint 0 is not as intense as later sprints. It is more reflective and has a slower pace. Sprint 0 usually has a runtime of several weeks, during which each team member spends several days preparing his or her own work. This may seem like a lot, but envision Sprint 0 as an insurance against wasted time. In Sprint 1, the boat sails full steam ahead and it had better be going in the right direction.

4.1 Strategic intake & research

Before designing and building things, you will want to know what corporate strategy your project is embedded in. You will want answers to some important questions, such as:

Questions about market & end-users:

◆ What is the company's vision and what is its mission?
◆ What are the main ambitions for the upcoming years?
◆ Which resources have already been assigned to realize these ambitions?
◆ How is the competition doing, and which direction is the market heading?
◆ Is there enough knowledge available of the customers or end-users of the products that you are about to create?

Questions about brand:

◆ Is there a defined brand? Is your client aware of it?
◆ What is the company's "tone-of-voice"?
◆ Is there a corporate visual identity? Is everyone happy with it?

Questions about touchpoint strategy:

◆ Which media and channels does your client use to reach customers? Which ones are successful and which are not?
◆ What will the new product's role be in the touchpoint strategy?

If certain questions don't get clear-cut answers, you can assume that additional strategies or insights must be created, for example by conducting more research.

> As a rule of thumb, we size a Sprint 0 to have as many workdays for each team member as there are Sprints in the project.

For some projects, we create extra user insight by carrying out street scans, interviews, and participatory design sessions. This book is not about how to implement these user-centered tools. We are saying that Sprint 0 is the time to acquire all of the necessary insights.

4.2 Product statement

It is rarely a good idea to just start creating great things. If all goes well, you will gather so many ideas that it will be hard to select the best ones, or the ones that are the best fit. This is why we use product statements. A product statement describes the main purpose of the new website or application. Later on, it will help you decide which features to prioritize; whichever feature serves the main purpose best should be built first. The product statement also describes a shared ambition.

Imagine you're at a party and you want to explain the project you're working on to the person next to you. This person is not professionally involved in design, so you have to get to the point and explain the project in one sentence. That is the product statement. Your goal is to get that person interested, have a great conversation, and enjoy the party!

> An example of a product statement looks like this:
>
> *trakz.nl is a trustworthy online music store, we are personal and passionate about music!*

Because we tend to formulate a product statement in terms of end-user benefit, we sometimes refer to it as the "product proposition".

Creating a product statement

Now how to go about creating a product statement? Here you can use many different creative techniques. We feel this is best done in a short (one or two hour) workshop, with all of the stakeholders on the client's side.

We start by writing down all the goals that everyone has for the new product on post-its. Be sure to try to find the goals behind the goals by asking: "Why?" After a while patterns will emerge, and there will be clusters of goals that everyone agrees on. These will form the basis for writing up the product statement.

You can continue the workshop by splitting the participants up into couples and having each couple write a product statement. Or, you can take the "clusters" with you and work some copywriting magic yourself. Either way, be sure to get back together and reach a conclusion about your ultimate product statement. If the team can't agree, the PO decides.

We usually cook up a catchy phrase, with callouts to explain its deeper meaning. This is preferably voiced from the end-user's point of view: "Site xyz.com provides me with..."

2 types of users:
- Quick user, knows what he wants
- Slow user, also open to be inspired and advised

:
o use
o find
pired
rprised

a *trustworthy* online music store, we

Trustworthy is about:
- Being honest and open
- Being transparent in your goals
- Being open about pricing
- Trusting TuneTribe with your personal details and payment

- Quality in product
- Relevant in suggestions/tips
- Reliable technique

Passi
- Bein
- Havi
- Crea

If you are unfamiliar with creating a product statement, this structure can be a big help:

> for *(target customer)* who *(statement of need or opportunity)* the *(product name)* is a *(product category)* that *(key benefit, compelling reason to buy)* unlike *(primary competitive alternative)* our product *(statement of primary differentiation)*
>
> *[From: Crossing the Chasm, Geoffrey Moore, 1999]*

What to avoid in a product statement

◆ Lengthiness—Too long, and it will be hard to remember.
◆ Vagueness—Too vague, and the product statement will no longer help anyone make a choice.
◆ Trying to please everyone—Every stakeholder has goals. Aim for the most ambitious goal that captures them all (or the statement will be too long and vague). Be bold, be strong, be ambitious!

Product statement workshop: agenda

20"	Workshop begins	Get to know any new people who have a stake in the product statement. Explain the reason and goal for the workshop.
60"	Discuss every possible component of the statement	-Target audience -Why we should care -What's special about the site -What the site will do for us
20"	Split up in groups and do a write-up	Try to write 5-10 statements in each group. Decide which one is best.
40"	Discuss the results	Improve on the statements of others.
20"	Decide on one statement	Vote—or let the most important stakeholder choose.

Focus on creating a visual language and don't do a BDUF (big design up front). Spend time on creating variations of "look and feel", not detailing functionality.

55

4.3 Design concept

Creating an online visual identity is a contemplative task that is hard to combine with the hectic environment of the Scrum room. So we usually create mood boards, basic graphic designs, logos, etc. *before* the actual first sprint. Also—based on the goals and product statement—the team may start envisioning overall concepts, solutions, and communication angles.

much sun

to redecorate

a new window

How should take care of my products?

Can my 20 year old blinds be fixed?

I have a problem and want to know I have hired a dealer

do eau nols?

I bought (moved into) a new house

I want Privacy

I want to replace old product

I want to keep up with trends

s it ng?

SERVICE & USE

I want my whole room in one style

ISP

What kind of window covering should I get?

Ads
online off

Word of Mouth

Google

go to dealer

TEXTURE & PATTERNS?

MATERIALS to fit my interior?

ELIVERED

indication of PRICE?

What is the window situation? privacy

What kind of ROOM

MOUNT the PRODUCT

"What kind of party are you going to?"

I need a nice reference

shown EXAMI price

How muc do I want to adjust the light?

I know what concrete things I like. I know what I have

I don't want to lose face when I'm at the retailer

What kind of furniture, floor etc does it need to match?

WAIT

PLACE ORDER

CO

- measure- ments
- color
- product
- operation

I want to find a dealer because...

I want to find a dealer because I want personal advice

measure

I want a cost estimate
→

These generic ideas will help in the creation of the backlog.

This is not a book about web design, so we won't delve into this in more depth. But we *have* learned the hard way that, for instance, lengthy discussions about logos can totally bog down a Scrum. Don't go there. By the way: this is not to say that there is no room for creativity when sprinting! (See page 124)

4.4 Technical solution outline

When you started the project, you had probably already done some technical research and made basic "make or buy" decisions. Sprint 0 is the perfect time to make the technical assumptions more concrete. Activities include charting legacy systems limitations, CMS characteristics and workflow requirements that may already be known. Remember the Scrum principle of eliminating waste. Don't create lengthy documents, and don't spend a lifetime on this. Fit it all on just a couple of pages if you can. Your work is going to be condensed into stories and tasks.

> Sprint Ø often yields the insight that much of the site's content is absent or incomplete. Real content requires strategy, planning and time. Start that content track right away.

4.5 Product backlog

The product backlog is the backbone of your project. This is basically your list of items, or "stories", to design and build. The entire team should know what's on this list and support its content. That said, there is only one owner of the list: the product owner (PO). He or she must make clear to everyone what's what. The PO gets to say which items are on top and will be created first—with, of course, some advice from the team.

Now how do you go about creating a product backlog? A *lot* has been said and written about creating user stories. Our method is actually pretty simple and yields good results.

We organize a workshop with the Scrum team. To do this, here's what you need:

◆ The finished product statement and any important sketches, site maps or technical documentation that you may have
◆ The complete Scrum team, including the PO
◆ A stack of XL post-its or empty story templates and big felt pens for all
◆ The user-story creation agenda, which is detailed below

20"	To rephrase project goals
60"	To write stories
10"	To add typical project stories
15"	To sort stories by priority
60"	To discuss the top 10-15 stories

Rephrasing project goals

Start the workshop by rephrasing the known goals for your project. Typical project goals are both factual and abstract. However, to make the creative juices flow, we rephrase them in inspiring ways. You can start by asking, "How do we...?"

Consider, for example, a start-up called ZeroTravelTime.com. The product statement reads: ZeroTravelTime.com helps me find jobs closer to home. Now let's assume their business model is based on advertising.

The project goals might be:

◆ To make a specific number of jobs available
◆ To get a certain amount of traffic to the site
◆ To earn a specific amount of money
◆ To convert a percentage of visitors into applicants

Rephrased product goals might then become:

◆ How do we collect lots of jobs?
◆ How do we interest job seekers?
◆ How do we interest advertisers?
◆ How do we help visitors make the trade-off between salary and travel time?

Can you feel it coming? You *want* to answer these questions right now. You know the answers. Let the stories flow!

Writing stories

Now each person takes a felt marker and a stack of XL post-its and starts writing. This works best if you write the story, then say it out loud as you stick your post-it on the wall.

If one person writes all of the stories, it won't work. The key thing about stories is that they are created, shared and understood by the team. Keep this in mind. The backlog is merely a smart collection of minutes taken from these conversations.

So how do we go about writing a good user story? Depending on "team and taste" we have three handy formats, ranging from abstract to concrete:

A) As a [role], I want [user need], so that I can [resulting ability] ≥ [short version]

Example: "As a user I want to be able to add a product to my shopping cart that allows me to check out multiple things at once" ≥ "add to cart"

- Pros: It is very strictly user-centered.
- Cons: It is long and complex for some teams.

> Don't hold back!
> Not All stories will make it to the project.
> In this step you will create A surplus of stories that the team And the PO will get to choose from.

B) As a [role], I can [do/view something]

Example: As a jobseeker I can filter jobs by distance to/from my home.

- Pros: It is relatively short and results in measurable user ability.
- Cons: It focuses broadly on user ability instead of user need.

C) [element or functionality]

Example 1: Layout and navigation
Example 2: Product detail page

◆ Pros: It's very clear in terms of what needs to be created. This helps teams who are having trouble with the semantic layering of option A or the wide, abstract solution space of option B.
◆ Cons: It may create tunnel vision and product centeredness.

Not all sentences in these formats are good stories. To determine whether stories are OK, use INVEST:

◆ Independent: A story should depend on others as little as possible, in order for priorities to be assigned easily.
◆ Negotiable: It is not a written contract, but an ambition to fill a need.
◆ Valuable to client or users: Instead of "Connect to the database through a connection pool", you have "With a five-user database license up to fifty users should be able to use this application".
◆ Estimable: There is enough domain knowledge and technical knowledge, and the size is overseeable. Not: "The HR Person can post jobs and pay for them online", which is way too compli-cated and vague. (Post jobs? How many forms does that take?) What are the payment options?)

◆ Small: It can be coded and tested within half a day to two weeks, by one or two programmers.
◆ Testable: It is clear what the definition of "done" is.

[From: User Stories Applied, Mike Cohn, 2004]

A story without INVEST points might read:

As a user, I can easily find my way.

This is an impractical story. It is not test-able and it is impossible to estimate.

An INVEST story might read like this:

As a user I can filter events with a specific date from a list

Put this way, the story leaves room for dif-ferent solutions, while it is reasonably eas to estimate. The end result is definitely testable.

Adding typical project stories

Stories which evolve from rephrasing goals usually leave important open spaces. Ther will be content and functionality which must be created, but don't typically emerge just by focusing on goals. The craftsmanship of you and your team will allow you to recognize that content. What will make your product more rounded and

complete? Here are some things typically included in a web project, which may require separate stories:

- Is any infrastructure needed?
- Are there typically required features, such as ways to register and/or pay (checkout flow) and contact options (such as forms)?
- Will you be reworking stories from previous sprints? Probably!
- Will you use dedicated polishing stories? In Scrum it can be helpful to initially build for one browser, then test and work on polishing up later.
- Will you have separate content stories? Content creation is usually part of your existing stories. But when the workflow doesn't permit this, you will have to create separate activities.
- Will you have one or more documentation stories? If you do need documentation, you may decide to write it at the end of the project or sprint, using separate stories.
- Do you need a style guide? Warning: *Only* write documentation that people will actually look at later on.
- Are legacy systems involved? If so, dedicate stories to clean up the legacy code. Standards and frameworks may have changed; comments may be missing. If this keeps the whole team waiting during the Scrum, it will slow the Scrum down.

Sprint 0 often offers the insight that much of the site's content is absent or incomplete. Real content requires strategy, planning, and time. Start that content track right away.

Sorting stories by priority

When you're done with the previous steps, you will have a stack of large story papers. You're not sure which of them will fit into your project, but you *are* sure that some are more important than others. The team has to sort them by priority. As the PO owns the product backlog, the PO has the final say in sorting things out.

Sorting by priority is fast and easy if you observe a few rules: (1) nobody talks, and (2) everyone can move stories around. Use a large table or the floor and start sorting the stack by priority. If you find doubles, choose the best and trash the rest. It's highly possible that while sorting you'll discover additional stories or have additional ideas and comments. Be sure to write them down.

Discussing the top 10-15 stories

The next step is to flesh out the stories for the first sprint. Discuss them in more detail and add comments. Write notes about the scope you have discussed and include reasons for the stories. It will help in the

decision making process later on. We often use a spreadsheet to keep track of user stories. This is shared with the team and always kept up to date, preferably by the PO. A typical spreadsheet looks like this:

Priority	User	Can Do [action]	Comments
1000	Visitor	Pinpoint the days and times when the museum is open	Simple table
900	Visitor	Browse calendar of special events	To help choose a day for the visit
800	Editor	Create repeat events	Repeats can be multiple time slots per day, whereby different days can have different time slots
...

For a story template (as displayed on pages 76/77), see:

fabrique.nl/getagile/stories

63

Expect to fail and don't give up!

Creating good user stories is actually the hardest part of Sprint 0. We provided you with some guidelines here but don't expect to create the perfect set of stories in your first-ever Scrum. Good stories are key to effective scrumming. Even after years of scrumming experience, they are often mentioned in retrospectives as a point of improvement: "We should have had better stories."

4.6 Definition of Done

When is a story really complete? When do we call it "done" and subtract it from the burndown? When the developer yells, "It's done"? When the PO has tested it? Or when we all just think it's really cool?

Scrum is a big driver of project speed. Your team will want to finish stories fast. In order to do this you need a solid cornerstone to maintain the quality required by you and the PO. This cornerstone is called the "Definition of Done" (DoD).

The DoD is essential for estimating how long stories will take to design and build. To avoid disappointment, it's important that the team has the same expectations as the product owner. A good DoD should include hard requirements, such as technical requirements or test scores. It should also include softer requirements such as our own ambition. How cool do we want to make it? How should it make you feel?

Below is a list of points to agree upon before starting. If they are critical to your product, add them to the definition of done and post them on the wall in the Scrum room.

Technical requirements

- ◆ Which devices should the site run on?
- ◆ Which browsers?
- ◆ Should it be documented?
- ◆ How should it be tested?

User experience

- ◆ How does it feel? Wicked? Rocking? Or just slick?
- ◆ Should stories be tested using external people?

Customer acceptance

- ◆ Who decides when done is done?
- ◆ How do you review stories?

4.7 Sprint 1: scope estimate

At this point you and your team should have a list of user stories sorted by priority and a Definition of Done. Now is the time to once again sit down with the team and estimate how many stories you can handle in one sprint.

Based on the size of your team and the number of sprint days per sprint, try to decide how far you'll get with the whole team. To do this:

- Get post-its and pens
- Have everyone consider the top part of the product backlog
- Have everyone secretly write down how many stories they think will fit into the sprint
- Share the numbers
- Have people with the lowest and highest numbers discuss their different insights and attempt to reach an agreement
- Re-estimate with the team. Carry on for as long as the team agrees and, more importantly, commits to the scope of the sprint.

Keep in mind that the estimated scope is not a contract. It's an estimate that can be adjusted later on. The key is to avoid getting too mathematical about how many stories will fit into a sprint. Experienced web teams are good at estimating how much work they can get done in two or three weeks. This is more accurate—and faster—than estimating each separate story and then calculating how many stories will fit into a sprint.

Once you've scoped out the first sprint, create a rough idea of the next sprints. Record them in the backlog (but don't spend too much time on it). This will give you a rough roadmap. If there are major discrepancies, it's usually best not to tackle them right away. Gather your observations from the first sprint and begin to work towards the end of that sprint.

For freshly composed Scrum teams, the first sprint will usually have less velocity.

Don't be too optimistic.

Better to underpromise and overdeliver – and don't worry.

The team will pick up speed.

4.8 Sprint goal

You now have the scope of the first sprint. It's time to summarize it in a phrase. This phrase will provide focus for the demo at the end of the sprint. When the stakeholders walk into the room, this is what we promise them. This also helps them to give you appropriate feedback. And having achieved the demo's goal, it helps you get that ultimate feeling of satisfaction.

	26/12	27/12	28/12	29/12	30/12	2/1	3/1
	MO	TU	WE	TH	FR	MO	TU
TRICK							
E-ANNE							
ANA							
EFKE							
TNEY							
CHAEL							
ELSON							
WILL							
ERRY							
GWEN							
BABY							
MAX							

MERRY X-MAS!

dentist

EVE

Here are some examples of good sprint goals:

- To impress management with a working console
- To set up a basic content page and agenda, so the content team can get started
- To get praise and encouragement for our progress on the product catalogue

4.9 Practical agreements

There are some practical things you will have to be clear about:

- Which days of the week will you work? This might seem trivial but the key to a good Scrum is to have everyone in the same room on the same days. Nothing breaks team spirit faster than people unexpectedly not showing up.
- Do you have everyone's phone numbers and email addresses? Write them down and post them on the wall.
- At what time will you start in the morning? In Scrum we start on time, because the first order of the day is a daily standup with the *whole* team. We actually suggest introducing a fine for lateness. Starting on time is important—and so is having fun with the team. So we agree on a fine for lateness, and we spend it on something fun once the project is done.

- Finally, at what time will you end the day?

The micro-planning of these events is also key:

- When will you have standup reviews throughout the day?
- When will you start the demo? Will it be held in the afternoon of each last sprint day?
- Who will attend the demo?
- When will the sprint retrospective be held?

We'll discuss these events in more detail in the next chapter.

4.10 Setting up the Scrum room

67

The last thing to do is prepare the Scrum room. You want everything to be ready and waiting when your team starts working in the morning. Keeping a team of 5+ people waiting while you fetch keyboards or seats is really expensive. Here's a quick list of things to set up before starting:

Hardware

- It goes without say that there have to be enough desks for your team, the PO, and occasional specialists you will receive.

Set up seats, keyboards, large monitors and Wifi/Ethernet for everyone. We usually bring laptops for flexibility.

Set up a color printer.

The room

You will need a lot of wall space. Scrum is about making things tactile and visible. So print everything and put what you're doing on the wall. It's easy to put post-its and comments on printouts, and the team will be better synched.

Set up a large, prominently located Scrum board; 2x2 meters should do. (More on the Scrum board below.)

Have a moneybox for latecomer fines. Decorate it by showing the kind of party you'll organize with the money. This may sound silly but it underscores the kind of work ethic that's vital to Scrum.

It's OK to share the Scrum room with other people who are not working on the project. But Scrum is noisy, so you'd better warn them.

Let team members make the room their own. Put your heroes up on the wall! And, yes, bring in that old Star Wars and Jakob Nielsen poster!

Supplies

Supply pens, super sticky post-its, rulers, scissors, markers, tape, sketching paper, and so on.

Software

Set up a shared virtual workspace. You'll want to share files and be sure everyone is working on the latest versions. Think Basecamp, Dropbox, VPN, GIT, or an ordinary file server.

Set up a fast development server. Make sure it can run real content and is accessible wherever you work and demo.

The Scrum board

The Scrum board is the "dashboard" of the sprint. It can tell you at a glance how the sprint is progressing; how focused the team is; and whether any unaddressed problems lie ahead. There are several areas of the Scrum board (or wall) which should ideally be situated close together:

The main story/task area: This should be a big, spacious area (roughly 2x2m). We create three columns: to do, doing, and done. These are not the official Scrum terms ("not checked out" and "checked out"), but we prefer to use everyday language.

Unplanned items: Use your head for thinking, not remembering. If you come up with any unplanned items, write them down and paste them on the wall. The PO and Scrum Master will deal with them later.

69

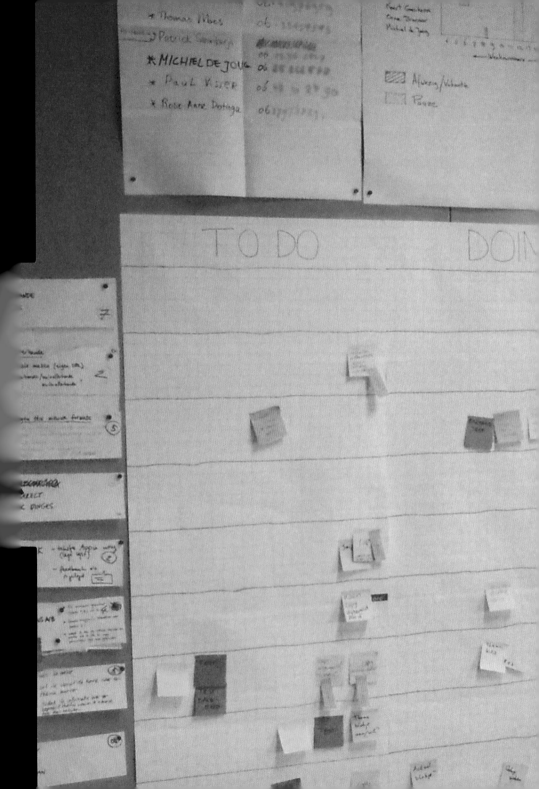

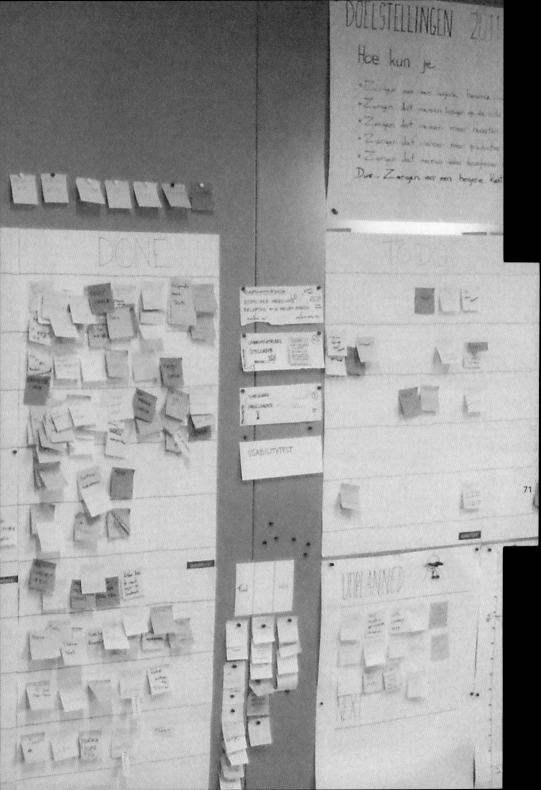

71

73

WERKT GOED OP IE8+, FIREFOX 5+,
CHROME 12+, SAFARI 5+

HET IS RESPONSIVE

HET STRAALT KWALITEIT UIT
(BAREND, FLOOR, SOFIE, COPY)

ALLE LINKS WERKEN

Done

Burn down

Unplannend

EDITOR

Crop tool

☐ U...
☐ Vi...
☑ Fr...
☑ Ba...
☑ Te...
—
☐ Co...
☐ ...

As a ~~user~~ editor / ...

i want to *be able to crop the header image in the CMS* so that *I don't have to buy Photoshop*

☑ Desktop ☐ Tablet ☐ Mobile

ACCOUNT

Log in w/ Facebook

☑ UX
☑ Visu...
☑ Fron...
☑ Bac...
☑ Test...
—
☐ Cop...
☐

As a ~~user / editor /~~ ...*new user*

i want to *log in with my Facebook account* so that *I don't have to create yet another account*

- Impediments: *Any and all* impediments should be written down and taken care of by the Scrum Master.
- The burndown chart: We often use a large flipchart with two axes for the burndown. Put the number of days the team will be Scrumming on the bottom axis and draw a dotted ideal burndown line. (The number of story points, the scale of the vertical axis, will have to wait until after the sprint planning meeting.) Put the sprint number and demo time on the chart, clear enough for everyone to see from anywhere in the room.

A Scrum board can be any surface you can write and stick things on. We recommend:

- Magnet boards—If you're a design studio, you probably have these. They make it very easy to move things around. If you have whiteboards or metal boards, use tape or dry wipe markers to create lines.
- With other types of walls—you can create a board using multiple 3M flipcharts or that "magic" electrostatic paper which sticks to walls without glue.
- We have also used glass walls as special see through Scrum walls.

You will fill the Scrum board after your first sprint planning on day 1 of Sprint 1.

Product backlog board

In addition to having the stories on the Scrum board, you will also want to display the product backlog in the Scrum room. This can be a simple, orderly grid of identified and prioritized stories; for larger projects (5 sprints or more) you can go pro. Like the Scrum board, we recommend also dividing the product backlog board into three columns: Identified, Prioritized, and Estimated.

- Identified—In this column, put anything that might relate to the product now or in the future—*anything*—from the most concrete functionality to the most abstract wishes. This can be formulated as user stories, but doesn't have to be. You might add: "As a user I want to be able to log in with my phone number, so I don't need to remember yet another username"; or: "Let's do something with Facebook". Anyone involved in the project—stakeholders, team members, even end users and of course, the PO—may add items to this column at any time. It is the PO's responsibility to keep track of newly added items and know where they come from.
- Prioritized—Once the identified items have been understood, the PO can assess their importance to the product and prioritize them accordingly.

Ideally, at this point, they become more concrete and are written down as user stories. It's a good idea for both the PO and stakeholders to frequently check this column, to see whether the priorities are correct.

▶ Next sprint (or ready for sprint)—The Next sprint section of the product backlog contains the expected sprint backlog for the next sprint. So, the stories in this section have to be made "ready for sprint". The success of the upcoming sprint depends on the preparation of these stories, so they require special attention of the product owner and in fact of the entire team. During backlog grooming (explained in more detail in the next chapter), they will be made even more concrete, and tasks will be defined around them to answer any important remaining questions. Are business rules and required content available? Do we have a rough idea on how things will work? You will have to answer these questions before the next Sprint planning meeting, or the team will not be able to start.

We sometimes keep two burndown charts: one for the current sprint And one for the entire project.

IDENTIFIED

PRODUC...

PRIO...

Geïntegreerd zoeken

Zoeken naar thema's

Zoeken naar Video's

ontwerp loaders

Receptenoverzicht

Nu in A...

LEZERSPANEL crossformat

REV

INTEGRATIE MIJN NIEUWSBRIEF

INTEGRATIE EIGEN RECEPTEN

INTEGRATIE GEDEELDE RECEPTEN

Archiefpagina
(onder in histoutie)
DELUXE

Video-overzichtspagina
videodetailpagina
DELUXE

DESIGN OPTIMALISATIE
(meer mogelijkheden voor MP)

Receptenzoekveld
in receptenpagina DELUXE

Receptenpagina
+ recept detail DELUXE

RECEPT UITGELICHT

contentpush
op in te stellen
tijdstip en
middernacht
(als een snekker)

INLOGGEN DELUXE
PROOF OF CONCEPT

SHAREN

RECEPTEN F...

ESTIMATED

READY FOR SPRINT

week
18
live

ina
NG
u..

week
20
live

HP

ONTWERP

betere
CTA

HP **Actualitiet**
communiceren
op homepage

HP **Lijstjes op**
epage

HOMEPAGE interactieve core/

carrousel?

canstplaat mer intensief 2 uitbreiend

VOOR ELKE DAG
ONTWERP LITE HP
DELUXE

KOOKLES (LITE)
Allebeurs 5.

JAMIE (LIGHT)
Allebeurs 2

RECEPTAFETTE (LITE)
Allebeurs 2

6 MANIEREN OM (LITE)

Diepte van
producties beter
ontsluiten

	wet pyg/y	wer pyg/y
Niet beheerd	A/B	X
wel beheerd	C	D

Epics versus stories

Items on the backlog don't always have to be user stories. If the PO has only a global idea of what's wanted, "epics" can be used. Epics are simply big stories. They are clear enough to be roughly estimated, but not yet concrete enough to use in a sprint, and often too big to develop in one sprint anyway. Before an epic is used in a sprint, it should be broken down into smaller user stories. But no need to invest time in breaking down a *low* priority epic, as it may never end up in a sprint. The higher an epic climbs up in the product backlog priorities, the more important it is to break it down. And if one portion of an epic gains more priority than the rest, it should be taken out.

An example of an epic might be: "As a user I want to have a collection of my favorite recipes, so I always have something to make." Even though this is written as a user story, it is rather vague. It doesn't say anything about how that collection will come about or how it will be used. So this epic actually contains several possible user stories. For example, as a user:

- I want to add recipes to my personal collection, so I can easily find them later
- I want to remove recipes, so there's no clutter in my collection
- I want to share recipes, so that my friends can enjoy them too
- As a first time user, I want to understand how My Recipes works. Then I may be inclined to try it out.

Eventually, epics should be broken down into smaller stories, but they can be roughly estimated prior to that. In fact, it's a good idea. It gives the PO an idea of their size and complexity, and triggers discussion between the PO and team about what is really wanted. However, as helpful as this estimation of an epic may be, the PO should remember that the team can't commit to this estimation. Commitment doesn't happen until the sprint.

4.11 Phew!

You've made it! And it may already feel like the whole project is done—but we haven't even built any product yet. Particularly for a large project, the various Sprint 0 tasks may seem overwhelming.

Back at the field HQ, it's time to roll up the map, lower the light, and apply your camouflage paint. Roll your thick magic marker between your teeth and say: "Ah luv it when a plaaahn comes togetha!" Let the action begin!

Treat Sprint ø more or less like a regular sprint: identify Stories and tasks to be done and stick them on the Scrum board.

83

5 Go sprint!

5

Go sprint!

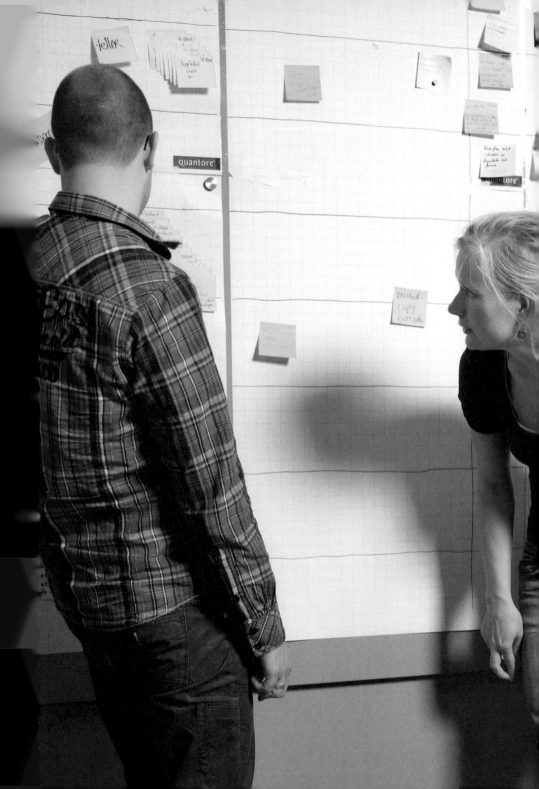

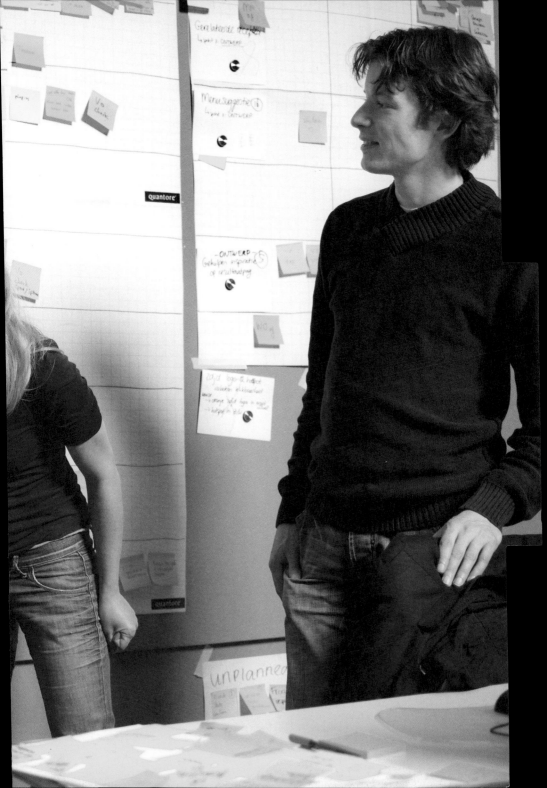

Well done! You've drawn up and planned your project; gathered information about your client and corresponding target group; formulated a collective image of the product and what it should accomplish; and you've already done some preliminary sketches. You're ready to start sprinting.

5.1 Sprint planning

A sprint planning is done with the entire team, including the PO. He or she must be present—if not full-time, definitely on the first day of each sprint. This is because the PO must explain the user stories, specifically their business value. And it's the PO who must reprioritize stories, if necessary. Moreover, you want the PO there to hear first-hand from the team about the amount of work that goes into user stories, and why. It is not uncommon for a PO to underestimate the complexity of seemingly simple functionalities.

Do your sprint planning first thing in the morning. Stop when it's time for lunch. A sprint planning should not take more than 3 hours, so try your best to finish before then. You didn't get it done? In the first sprint, when it's all new to you, continuing after lunch can be forgiven. Otherwise, just start the sprint, even if you don't feel you're done. You can complete the sprint planning later.

Determining the Sprint backlog

The main goal of the sprint planning meeting is to determine the sprint backlog. (You've already done the groundwork in Sprint 0.) Here, again, we strongly believe in doing hands-on Scrum meetings using post-its, paper, walls and boards, rather than screens, pixels, and files.

The team should be critical of the PO's stories. Is it clear why a story exists? Keep asking "why" until it becomes clear. Are the stories good examples of INVEST? Stories that are too vague should be made more concrete or broken down into specific user stories. (See page 59, for more on the creation of stories.)

If it takes too much effort to estimate a story on the spot, return it to the PO as a story that's not yet "ready for the sprint". See Handling complex stories in the next chapter, page 100.

Determining backlog for
beginner teams or sprint 1

In the first sprint, the complete estimation process is quite a lot of work, so stay focused.

◆ Sprint planning starts with a discussion of the stories that the PO wants the team to tackle in the sprint. Discuss each story briefly. This part is often referred to in Scrum literature as "Sprint Planning I". If the PO is well prepared, each user story will have already been written on an index card. And there may already be some designs, which should be printed out.
◆ For each story, write down tasks on post-its and paste them on or next to the user story cards. (More on Task writing below.)

- Ask the whole team to arrange the stories in order of complexity on a large surface: largest story on the left, smallest on the right. Do this in silence for 3 minutes or so.
- Take the second smallest story and give it 2 points.
- Use Planning Poker to have the team estimate the other stories in relation to the 2-point story. (More on Planning Poker below.)
- Rearrange the story cards, this time in order of the PO's priority (business value).
- Ask each team member to put a random object (like a poker card or pen) on the last story they think they will be able to complete in this sprint (according to the Definition of Done). Everyone does this at the same time, so as not to influence each other. It will then become clear how many stories the team thinks it will be able to achieve in the sprint.
- Ask the PO if this is acceptable. If not, challenge the team to think of ways to do more in the sprint. This is a very important step. Are there any redundant tasks? Can we think of smarter solutions? Can we swap large stories for smaller stories?
- Ask the team to commit to the sprint backlog.

Really put the P.O. in charge of preparing the backlog and its stories. Scrum masters are often tempted to take care of this, but it compromises the P.O.'s sense of responsibility.

89

Determining backlog for experienced teams

Once the team gets the hang of it, sprint plannings can become leaner and faster:

- Lay out the stories for the sprint in order of priority
- Briefly discuss each story

- Use Planning Poker to estimate the stories in relation to one or more typical stories from previous sprints (reference stories)
- Decide which stories the team will tackle in the sprint, and check this with the PO
- Write down tasks for each story—in silence
- Ask the team to commit to the sprint backlog.

Here, identifying tasks *after* the estimation saves time and discussion. But this is only for more experienced Scrum teams, who have a good understanding of each other's work. You can also write the tasks before the estimation, so that it's easier for teams to estimate the complexity of a story. Keep it short, though. Don't go into too much detail.

Are we going fast enough?

When providing estimates, the team does not have completely free reign. During the sprint planning the Scrum Master and PO consider the team's past speed. Along with the newly made estimates, this can indicate what the team should be able to accomplish. And if the team's not up to speed, everyone can look and see what could be done about it. Could there for example be a more straightforward implementation of certain functionalities? See also our Troubleshooting chapter, page 136.

Creating tasks

We've just talked about breaking down stories into tasks. But how does this work? It's actually quite simple. A task is anything that needs to be done to bring a user story to the "done" state. We can't tell you what those tasks will be. You are the expert when it comes to your own project. The tasks will be different for each team and each project. But in a typical web project, tasks will most likely be identified in the following categories:

- Interaction Design and Usability checks
- Visual Design and VD checks
- Front-end development
- Back-end development
- Work for the client/external parties
- Copywriting
- Testing

Remember that the PO is part of the team, and also has tasks. Typical PO tasks include:

- Discuss result X with stakeholder Y
- Create, arrange, or deliver content
- Deliver a communications calendar
- Set up a maintenance program
- Arrange contact with third parties, such as Google, a hosting provider, and so on.

To more easily identify tasks, use a different color marker for each discipline. Then it will only take one glance at the Scrum board to see how far a certain discipline or type of work has progressed.

91

If you fear that something may be overlooked during a sprint, turn it into a task. For instance, if good usability is very important for the new product, make "usability check" an explicit task for each story. That way it's impossible to miss. The story simply won't be "done" until that post-it has been picked up by a team member. (Read more about integrating usability and user centered design, on page 125)

Each team member identifies the tasks they think need to be done and writes them on post-its. To identify tasks more easily, use a different color post-it for each discipline. Then it will only take one glance at the Scrum board to see how far a certain discipline has progressed. You will then be able to see, for example, that all the design tasks are already "done", but many development tasks are still in the "to do" or "doing" columns. (A *vice versa* situation would be rare within one story, but not unheard of.)

The trick is not to write down every single activity, but to not be too abstract either. The guideline: If a task can't be done in one day, break it up into separate tasks. On the other hand, don't waste time writing up detailed tasks—spend that time *doing* them. If your team's tasks don't fit onto the Scrum board, you have too many tasks per story. Either your defined tasks are too small, or your stories are too big.

Should work on the CMS be separate stories or tasks in a 'front-end' story?

It depends. If CMS work has to be done in order for the front-end user to be able to do something, consider it a task. For examples, if you're building CMS functionality especially for the content editor (e.g. "schedule content push"), then the editor is the user and gets a separate user story.

Planning Poker

To estimate the size of stories, we use a game called Planning Poker. This is an Agile practice that combines fun with efficiency. Instead of calculating the resources needed to accomplish a certain story, the team gives estimates that are relative to each other, expressed in "story points". The estimations are confined to a fixed range:

$$? \mid 0 \mid 1 \mid 3 \mid 5 \mid 8 \mid 13 \mid 20$$

We'll talk about the value of these story points in a minute. But first let's walk through the steps. This is how Planning Poker works:

◆ The team discusses the story
◆ Each team member chooses a card, in silence. Choose the number that you think corresponds with the effort that it will cost the *whole* team to bring the story to "done". Don't think too long. Just follow your gut feeling — and don't let other team members see your card just yet. You don't want to influence them. You really can't estimate? Then pick the question mark. Do you think the story has already been solved? Then choose zero.
◆ On the count of three, each player reveals their card, at the same time.
◆ Did everyone choose the same number? Great! Write that number on the story's index card and move on to the next story.

◆ Not all the same number? Then let two team members with the highest and the lowest numbers argue. Why does one person think it's only worth 2 points, while another chose 20 points?

◆ Repeat this loop until the team reaches a consensus—but don't go on endlessly. Does one person keep choosing the same high number, while others choose lower ones? Then ask that person how the story could be done differently to end up at that lower number.

◆ Write the chosen number on the story's index card and estimate the next story.

The secret to a fast, efficient Planning Poker session is silence. First let the cards do the talking. Save discussion for *after* each estimation. If everyone estimates the same number, you don't need to discuss and can just move on. It's up to the Scrum Master to keep the pace up and cut short any discussion that is taking too long.

Why estimate in story points?

It is very helpful to disconnect the actual man-hours or workday capacity from the amount of work being done in the sprint. A team's efficiency increases over time. Meanwhile, it might be on a roll or having setbacks; it might estimate too pessimistically or optimistically. With the estimates of the last sprint in mind, a team might feel it can do more or fewer story points in the upcoming sprint. The total story points achieved in a sprint are called the sprint's "velocity".

For beginner Scrum teams who are uncomfortable with story points, it might help to plan your first sprint using man-hours or workdays instead of story points. Do avoid "calculating" your estimations, however, and go for what feels right. After one or two sprints, the team will get a sense of the size of the numbers.

Why estimate using rough numbers?

The whole idea of Planning Poker is to provide an estimate, not a calculation. Estimates are rough by definition. That's why combining cards is not allowed. If you want to choose 10, you can't combine 2 and 8; you have to choose either 8 or 13. (The numbers are actually a Fibonacci sequence. Google that sometime if you're as geeky as we are!)

Sprint goal

As discussed in the Sprint 0 chapter, it helps a lot to define a sprint goal. The goal doesn't have to be about the product, it can also be about the team. This keeps the team and the sprint focused. You can't summarize the whole sprint in one sentence? Don't force it. It's not a must-have.

Using the Scrum board

When you know what you are going to do and how much effort it should take, you're ready to put it all on the Scrum board. Now is the time—if you haven't already—to create the actual story sheets. (See page 59) User stories should be clear from up close and "from afar". If someone on your team likes to sketch, draw a small picture on each story card as well.

Another fun thing is to make "mugshot magnets". To make these, simply cut out photos or prints of team members and tape them to small magnets. We use these to put the tasks on the Scrum board, so everyone can see who's doing what. You can also make name labels using strips cut from post-its.

What if all the stories and tasks don't fit on the Scrum board?

Well, that's usually not a good sign. Either your stories are too detailed or you have too many tasks. But if you really think you can do all those stories in one sprint, simply try it. Put the superfluous stories and tasks aside until one or more stories are done. They should be the stories at the top of the board.

Then take these away and move all the other stories up. A new space is created at the bottom of the board, where you can now hang the extra stories. Rinse and repeat.

5.2 Daily standup

The daily standup is the day's kickoff. So it should always be held at the start of the day. The exact time doesn't matter as long as everyone agrees on it. We find that sometime before 10:00 a.m. works best. As always: timebox it. For instance, a team of 6 people shouldn't need more than 15 minutes for the standup. Here's how the daily standup goes down:

Do a round

For beginner Scrum teams, do three rounds to get a short answer from each team member to these three questions:

◆ What have you done since the last standup?
◆ What are you going to do today?
◆ Do you have any impediments (obstacles) or problems for the Scrum Master to solve?

An experienced Scrum team can do one round and have each team member answer the three questions at once.

Make sure you stick to this format and don't discuss things that are not relevant to the whole team. Don't let the standup become a meeting in which decisions about the product are made. It's a quick update: nothing more, nothing less. There will be time for your questions or opinions later.

Update the Scrum board

When the team members say what they've done or are going to do, they should be moving their tasks on the Scrum board. It's important for the owners of the tasks to move the tasks themselves. The Scrum Master should not be a project manager, moving tasks for others! Remember: Scrum is about self-propelling.

Update the burndown chart

Before the end of the standup, the Scrum Master updates the burndown chart, and the whole team can see how they're doing. If the team is having trouble following the ideal line, they should discuss the possible causes and think of ways to speed the team up—or lower the PO's expectations. Don't worry that the PO will see the truth. Embrace the transparency of Scrum. If the team works hard and smartly, the PO will see this.

Non-team members at a standup?

It's fine for people outside the team to attend the daily standup, like stakeholders. However, they can only watch and listen. They are not allowed to speak during the standup.

5.3 Daily reviews

In Scrum, it is essential not to wait until the demo for the PO to see results. The way we use Scrum is like cooking: you're constantly tasting what you're making. This translates into daily reviews, when the team and the PO come together to take a brief look at the latest designs or version of the working product.

Depending on the team's velocity and needs, one or two reviews per day is plenty. A review may take as little as 5 minutes and should take no longer than 30 minutes. You don't want the team to feel like they're spending more time on reviews than actually designing and developing.

Fixed times are good for getting a steady rhythm going, e.g. 11 a.m. and 2:30 p.m. But don't sweat if you occasionally skip one.

Design reviews

At design reviews you will need, at the very least, the designers involved, the art director, the lead developer and the PO to be present. The lead is taken by the designer, who presents the work.

- Start by framing: Which stories and tasks have been executed? What have we already agreed on?
- When discussing the design, keep an eye on story point estimates. When designs emerge and become a focus of attention, stories can easily get out of hand.
- Write down evolving tasks and paste them to the board, possibly replacing older tasks, regardless of whether they have been checked out or not.

Product reviews

If you're doing an *überScrum*, the only thing that really matters is the working product. That's why it's so important to look at it frequently, with the whole team. We guarantee that if you don't, there will be minor imperfections remaining in the product, which you'll wish you had taken care of when you had the time.

Walk through the user stories as you would at the sprint demo (and as the end user would). Each team member writes down

> It is better to tackle a disappointing burndown chart by adjusting the scope, or by spending less time on story solutions. Going for extra time is hardly ever a sustainable solution.

any issues they see and that they can solve themselves. Is it necessary to do another visual design check? The visual designer handles that. Did you find a bug? That's the developer's task. Spotted a spelling error in a text? Anyone with access to the CMS can fix that one. Rely on the self-propelled team, and let everyone spot and write down their own tasks. It's important for the Scrum Master to resist the urge to hand out tasks like a project manager.

n the last Scrum day, you definitely want
o do the daily product review with the
whole team. Then, what the stakeholders
et to see will hold no surprises for anyone.
his is also the opportunity to spot those
ast flaws and clean them up before the
emo.

.4 Backlog grooming

he founders of Scrum advise teams to
pend 5% of their time on "backlog groom-
ng". This means discussing the backlog
with the PO, determining high priority sto-
ies, and making sure they're well written.
he PO is responsible for this happening —
ut obviously needs the team's help.

or small projects, most if not all user
tories may have already been defined in
print 0. In this case, backlog grooming
may simply mean detailing user stories;
r combining stories, if that makes more
ense; or even eliminating stories that
rove to be obsolete.

or larger projects, user stories are being
developed continuously. In this case, back-
og grooming may also include discussion
f the newly added stories and getting
sense of how to realize them. The PO
eedn't always do this with the whole team
nd may choose to invite just the leads
rom each discipline.

As stated in the previous chapter, special
attention goes out to the stories that are
expected to be taken on by the team in the
next sprint. This expected sprint backlog
for the next sprint is determined by taking
a look at the team's velocity. For instance,
if this velocity is 50 points per sprint, the
next sprint backlog will have to be filled
with stories that approximately total that
amount. These stories will be taken out
of the Prioritized section of the product
backlog, and put in the Next sprint section
of the backlog.

From there, they will be made ready for
the next sprint. The PO will discuss them
with the team or team leads and tasks will
be defined around them to answer any
important remaining questions. Are busi-
ness rules and required content available?
Do we have a rough idea on how things will
work? You will have to answer these ques-
tions before the next Sprint planning meet-
ing, or the team will not be able to start.

During backlog grooming, at least once per
sprint, the team looks at the entire product
backlog, and does a scope estimate. With
our current velocity and with the fixed
number of sprints that are planned for the
project, how far down the backlog do we
expect to get? What stories will almost cer-
tainly be finished? What are the stories the
team will probably not be able to start on?
In the middle there is an area of uncer-
tainty that is inherent to flexible scope.

The PO will have to decide if the estimated range is acceptable. If not, no disaster, but it might be time to start Trouble shooting. See chapter 7.

Ideally, backlog grooming is done daily, but at least once a week. Like cleaning your house, frequent short sessions are better than an occasional long grooming session.

Handling complex stories or epics

For more complex stories or epics, separate "sizing sessions" can be organized. Call in specialists from outside the team. (They may join the team once the user stories end up in a sprint) Discuss what you want to achieve with a story or an epic. The specialists can help detail the user story and come up with various solutions.

A good practice is to come up with three different versions, or "flavors", of a story solution: solutions that may differ in complexity. We call them "light", "medium", and "deluxe". The *light version* is the most minimal solution you can think of. As simple as using the CMS for example, which requires no programming at all. It may not be the best or most elegant solution, but it's better than nothing. The *deluxe version* is the ideal solution: it's the most usable for the end user and/or the most technically sustainable. The *medium version*, you might have guessed, sits somewhere in between.

Finding the time to update the Backlog

We admit it: You can't look at the product backlog often enough! It helps to have a good PO, who is willing and able to remind the Scrum Master and team—on a frequent basis. Don't do daily estimates right after a standup, or whenever you feel the team is "flowing" and shouldn't be disturbed. Find a time when people can spare 5 minutes. If not everyone can come, work with one representative from each discipline: one designer or one developer. And as always: Timebox it!

By considering the light, medium, and deluxe options, a team is, first of all, challenged to think of different solutions. A simple solution may be good enough, especially when the story isn't critical to the product.

Secondly, having different "flavors" gives the PO more choice about how story points are spent. Is the story really worth spending all the points on the deluxe version? Or, would the medium version enable the PO to save some points for those other stories the stakeholders are pushing for? Having more choices makes discussions with stakeholders much easier.

If the PO feels there is too much assumption involved in the process, he may plan a Spike. A Spike is the creation of an ex-

perimental, timeboxed solution: perhaps a sketch, a prototype, or a piece of experimental code to help estimate the story. Spikes are intended to help with estimates only; the results are generally thrown away.

Otherwise, we handle Spikes the same way we do stories. We make them ready for sprint, plan them, estimate story points and write tasks. This way they are embedded in the usual workflow and they add to the team's velocity.

[from Adam Sroka, 2009 http://tech.groups.yahoo.com/group/Scrumdevelopment/message/42889]

5.5 Sprint demo

The final sprint day

So, it's the last day of the sprint. You have all worked flat out for two or three weeks. Now you're about to experience the moment of truth: showing the product to the stakeholders. Will everything work? What will they think? Relax. If you have an efficient Scrum team, the demo will be a walk in the park. But this takes some discipline.

At ease with Code Freeze

Don't plan to work on the product right up until the last minute before the demo. Unexpected things always seem to happen on the last day: Adobe Fireworks keeps crashing; Google Chrome isn't installed on the demo computer. Anticipate these things by making sure you have a working, demo-ready product, well before the review starts. In other words, have a "Code Freeze" and stick to it. Spend the last hour cleaning the place up and getting everything ready for the stakeholder's arrival.

The demo itself

All team members are present at the demo. It's important for them to hear the feedback from the stakeholders personally. This provides a sense of direct responsibility. The demo is not only a demonstration of the product; it's a review of all of the sprint's different facets. Do give the stakeholders a brief glimpse of the way the team has worked together, and (hopefully) how they've improved.
This is more or less the way we do our sprint demos:

- The PO welcomes the stakeholders
- A team member (usually the Scrum Master) goes on to
 - Mention the sprint goal
 - Review the "definition of done", to manage expectations
 - Mention any preconditions and constraints
 - Explain the process of this sprint. Which impediments did the team come across?
 - Mention the user stories

Should we prepare a PowerPoint presentation for the demo?

We like it when things aren't too formal. A PowerPoint presentation comes across as professional and can help to clarify the demo. But don't put a lot of effort into making a really slick presentation. We use a standard template and just rewrite the slides each time.

Remember: slides have no value to the stakeholder; a working product does.

◆ Walk through the working product, explaining the decisions you made —or take the "stakeholder test". (See below.)

◆ The team answers questions and receives feedback from stakeholders. Let any specialist on the team answer questions; don't make it the Scrum Master's Show.

◆ If your team can pull it off, you might inspire individual members to demo specific stories themselves, especially those they really care about or the ones they've put a lot of work into. The CMS for instance, is often best demoed by the developer who put it together.

◆ Have one (or more) of the team members take notes. Post-its are a good idea.

If you Are going to receive your Stakeholders for A demo, clean the Scrum room up A bit!

◆ Tell the stakeholders that they can give the PO additional feedback.

◆ Thank everyone for their individual contributions.

The stakeholder test

In the previous section, we suggested walking the stakeholders through the product process. A nice alternative is to let everyone use it themselves. Instead of just showing it, If you have enough workstations, give each and every stakeholder their own computer. Give them tasks.

It's better for people to experience the product for themselves. Not only that, it can be seen as a usability test. Monitor your stakeholders' activity. What are they looking at? What are they clicking on? Do they understand how the website works? Where do they get stuck? Watch and take notes!

You may need to nudge stakeholders a bit. Some won't be accustomed to having to "work" at a presentation. Try to avoid pairs sitting together at one computer. It's much more valuable for stakeholders to operate the mouse themselves. Depending on the tasks, this shouldn't last longer than 10 to 15 minutes. You don't want your stakeholders waiting around or feeling they're wasting their time once they've finished the tasks.

Stakeholder discussion

Stakeholders usually have many (conflicting) opinions. So how do you keep the review short—but not have the stakeholders feel they couldn't say everything they wanted to say? It's a good idea to have the PO organize a short round-up discussion with just the stakeholders, directly after the demo. This allows stakeholders to reiterate feedback they may have already given, or offer additional feedback that they couldn't or didn't want to say directly to the team. The PO collects this feedback and passes on the most important bits to the team.

Determining time & duration

When? Always in the afternoon, but no later than 4p.m. How long for? Aim for a demo lasting 90 minutes. Shorter is fine, of course, but try not to make it much longer. This will only lead to long discussions that won't really give the team much more to go on.

Where does the demo take place?

We are firm believers in holding the sprint demo in your own office. There are a number of reasons for this. First, the whole team is already there. So valuable time that could be spent on the product isn't lost in travel. But there are other reasons to demo at the Scrum location. Demo products usually work best on the local network. You don't want to risk the product

not working well on a different network, or having to create an offline version on a laptop. Moreover, stakeholders can see where the product was actually created.

Some clients are reluctant to travel and invite you to demo at their office. Try to negotiate. See if you can alternate locations: perhaps sprint reviews at your office, and the odd review at the client's office. Although not ideal, we have also done sprint demos whereby some stakeholders joined in remotely via teleconferencing and screen sharing. And if all else fails and you must travel to the client, select a group of team members to go with.

Celebrate!

The good thing about Scrum is that everything happens in a certain rhythm. Sprints are always the same length; you work on fixed days; the standups and reviews are always at the same time. Like clockwork.

Likewise, at the end of the sprint, always celebrate achieving another goal. Wind down with the team over dinner or drinks. Don't underestimate the importance of finishing each sprint in an informal way. This is above all nice for the team, including the PO, and helps with team bonding. Invite all the stakeholders, too! After all, you're all in this together. We usually celebrate with drinks and snacks at the office. But during

a long Scrum project, you may also want to go out somewhere nice once in a while.

5.6 Retrospective

"Inspect and adapt" is one of the key principles of Scrum. Because you can't adapt without inspecting it's crucial to do a team retrospective after every single sprint. Never ever skip this. You don't think you have time? It can be done in 10 minutes. We guarantee it. The trick is to do it mostly in silence and, again, timebox it. Here's how to do fast but effective retrospectives:

◆ On a whiteboard, flipchart or a table, create a horizontal timeline showing the days the team worked on the sprint.
◆ Then have each team member grab some pink and green post-its and markers. Spend no more than 2 minutes on this. Have everyone write positive things about this sprint on their green post-its, and not so positive things on the pink ones.
◆ Paste the post-its onto the day the learning occurred. Was it a general trend? Just put your post-its anywhere on the board.
◆ After 2 minutes, take a look at the board together. Can you spot patterns? Do pink or green clusters form around certain moments in the sprint? What is the green to pink ratio?
◆ In the next 5 minutes briefly discuss

107

what you all wrote and group similar post-its together.

- In the last 2 minutes, pick no more than three things which were learned: things you want to improve on as a team. Be sure to mention these points again at the next sprint planning.

What if you can't do the retrospective directly after the demo?

It's no disaster if circumstances prevent you from doing a retrospective right after the demo. However, do be sure to do the retro before the next sprint planning. You don't think you have time?

Again, it can be done in 10 minutes. Ask the team to come to work 10 minutes early, or just delay the sprint planning for a bit. No biggie.

Should the product owner be present?

It depends. If you're doing a Scrum with an actively involved PO, who has their own tasks on the board and who is basically one of the team then, yes, the PO joins in with the retrospective. But if you feel that the PO's presence might prevent some team members from reflecting openly and honestly, it's wise to do it without the PO.

5.7 Final retrospective

Another good thing about Scrum is that there's no need for long and tiring post-project evaluations. You've been doing retrospectives for every sprint. You do want to do a final evaluation, but you can keep it just as brief as a normal retrospective, using the same technique. We like to do final retrospectives right after the demo of the last sprint. Then everyone's together; the memories are still fresh; and you don't have to plan a new meeting. When the final retrospective has been done, the project is finished. And, of course, after sprinting there's nothing quite like the thrill of crossing a finish line!

To do a retrospective of an entire Scrum project, we also use the timeline method. But instead of using a timeline with days, you can draw a timeline with sprints. You could also add the days of the last sprint, thereby combining the final and regular sprint retrospective. Once again, use green and pink post-its for your positive and negative experiences and discuss them. For reference, take a picture of the result. You could also document them in written form and share the outcome with the PO and other Scrummers in your organization.

Congratulations, you've finished your project! Off to the next Scrum...

By Pieter Jongerius

6

Sprinting Secrets

POTE

QUO

"Je boterha

Gaan we
daar heen
omheen
bouwen?

we weer
lies bij het
FabriquL – occupy ·park"

– Garton –

Vraager:
hoe designers

If most of what you have read up until now seems like child's play, it's time to become more ambitious. In this chapter you will find a number of insights that will help improve the success of your Scrum projects.

6.1 Integrating UX and development

A hot topic in many publications is the Agile integration of User eXperience design (or UX) and development. Bringing interactive design, visual design, copy and development much closer together guarantees that our Scrum interpretation is Agile. We have seen that the level of success in this area depends on many factors—especially social and psychological ones. It's all about the team. It is not just experience that counts, but also courage and open-mindedness.

We use two different models for parallel development and design. But before taking a look at them (below), it would be a good idea to revisit the Agile UX & Development principles (see the inside cover of this book).

Staggered sprints

First, we have staggered sprints. This is a rough model that gives designers a one-sprint lead over developers. Each sprint produces two types of stories: finished design and finished developed product. Each has its own Definition of Done. The sprint demo is also made up of these two components. You may even decide to set up two Scrum boards —as long as the team stays in the same room! The sprint planning, daily standup, and other reviews are also done with the whole team.

Staggered sprints offer a number of advantages:

- A clear overview of the project—As with waterfall, all stories go through a design & development phase. This makes them comprehensible and therefore less daunting for seasoned waterfall users.
- Because the whole team is always in one room, working on the project simultaneously and reviewing it together there is much more peer supervision than in classic waterfall.
- This can be a safe approach in situations where the PO has limited mandate and must check many things with the stakeholders. The designs get a seal of approval before they are developed.

There are also some significant disadvantages:

- A substantial chunk of waterfall remains. This means that more designs may be created than is necessary, and that iterations are more expensive. In fact we sometimes jokingly call staggered sprint projects "waterScrum".
- It's much trickier to maintain a healthy capacity distribution between design & development. The true impact of specific designs only becomes apparent after a week or two.
- Editors are in limbo and go from one story to another. Which copy is needed

in the design phase? Which copy isn't needed until the implementation phase?

ÜberScrum

We have respectfully called the second model *überScrum*. In this model we try to design and build as many stories as possible in one sprint. Nowadays, we use this model for the majority of our Scrum projects. In the past we tried to have all stories designed and built during the demo. But this requirement was dropped as it put too much pressure on individual team members at critical times and led to inefficiency. In practice, it is feasible for approximately two thirds of the stories to be completed straightaway.

It is important to stick to the policy of only showing in the demo what has in fact actually been completed—whether it's a finished product component or finished design. We have learned it's a matter of personal taste whether you separate design & development stories and Definitions of Done in überScrum or staggered sprints.

The following three insights will help you in überScrum:

◆ ÜberScrum is challenging for team members. They must really keep after one another and dedicate time to comprehending each other and focusing on shared goals. You'll have to stress this in the sprint planning and carry out reviews with the entire team.

◆ Skip design where possible—However you look at it, the basic cycle is always the same: design, development, test and review, and implementation. Look for situations whereby you can omit or reduce the first step, i.e. design. A design is an intermediate communications outcome—replaceable with other forms of communication, such as an explanation or clearly written stories and tasks.

◆ Assumption is the mother of all f*ckups *(Eric Bogosian in the Steven Seagal-helmed film Under Siege 2, 1995)*—"But," you might say, "assumption is also the driver of inno-vation!" You are right. But what we're looking at here are the assumptions about other team members' intentions. Designers should make as few assumptions as possible to ensure their designs are technically sound and compatible with data models, standard functionality, and so on. Developers must also make as few assumptions as possible about what a design implies—and consult with designers on a frequent basis, thus playing a role in determining the designer's agenda.

Story types

In traditional Scrum, all stories are in essence the same and may be done by all team members interchangeably. However stories are often quite different from each other, some being more challenging in terms of design, while others will give developers a run for their money. So it's safe to say: not all stories should be alike. This is why we invented story types. They are the key to efficiency in Überscrum.

We usually identify four story types:

◆ Überstories. These stories get to be designed, developed and tested in a single sprint. As a consequence, tasks include most disciplines. The result is a finished product part. If the team functions well, überstories should be the majority of stories.
◆ Development only-stories. As said, skip design where possible. Especially if the Scrum has been running for a couple of sprints, patterns begin to emerge, and a design isn't always needed. A developer can complete the story based on the input from the PO. A designer may still keep an eye on the execution.
◆ Design only-stories. Some stories can expect massive stakeholder input, wich will require heavy iteration by the visual or interaction designers. Homepages are well known examples of stories or epics that are best dealt with by defin-

ing design stories first. Demo these stories as finished design. If approved of, they will be found on the backlog of subsequent sprints as development only stories.
◆ Spikes, as explained on page 102.

We define the type of each story during sprint 0 or backlog grooming. Also, during these moments, we consider the ratio of different story types in the sprints to come to accommodate discipline capacity. Story types not only reduce waste, they also help in spreading the work load during a sprint. It can be wise for developers to start with development only stories while designers quickly start working on überstories. Later during that same sprint developers switch focus to implementing the überstory designs. Designers can then continue working on design only stories. Tests and documention follow directly within these stories. Depending on priority spikes are mixed in.

TIPS for design & development

◆ Don't try to attach UX to an existing development Scrum. If you want to remain agile, design cannot be a pre-requisite. It cannot be on a definition of ready (see page 122). If you want design to have impact, UX design cannot be some advisory group to the PO, who'll decide what to turn into stories, and what not. Eliminate this waste: step up

REISADVIES SUGGESTIE

onduidelijke ~~~

REISADVIES

LANDING

TITEL

CONTENT #1

TITE

as a single team and create shippable products together.

- Stop acting like a spoiled princess! You will have to make compromises. Scrum is give-and-take. Designers must for instance face the truth that some things are unaffordable to build. Developers must invest in going the extra mile to create better UX.
- There is not one way of interdisciplinary cooperation that will work for all of your projects. Inspect and adapt. Don't try to stick to "the best strategy".
- Work with a basic design and modules that can be applied at will, so you don't have to keep creating full pages. Identify the no-brainers early on in the sprint. These standard patterns and components may include FAQ sections, standard content pages, and contact forms. Developers often get to work on these more than designers do.
- Use spikes often. Before you do final design & development on complex functionalities, prototype them. Prototypes may be paper, click dummy, quick jQuery animations, etc. Often, front-end developers do have time for this at the beginning of a sprint.
- The code quality is extremely important. Be flexible and fix things as late as possible. By making code object-oriented and parametric, the various team members can tweak it at a later stage without actually reworking it too much.
- Establish a development "code of con-

duct" (see below), whereby the developers identify the steps to be taken an the tests to be done in order to guarantee quality—regardless of any inheren haste in the sprint.

- Are you building up technical debt despite your best efforts? Write the major issues down on post-its and pos them in a "Technical debt" area on a wall. It's so much easier to convince th PO to allocate room for refactoring if you see debt piling up.
- Beware of "happy flow" blindness. Make sure that the team also specs ou exceptions.

TIPS for work methods

- The product backlog must be more concrete than ever. As there must be a very clear idea about the rough functionality, such as flow, determining and identifying stories may entail more effort.
- In überScrum it's vital that the team doesn't work on too many stories at once. Despite the use of story types, yo need them to be working on the same things as much as possible. Then communication is not only more efficient, it occurs more frequently, because team members don't feel they're interrupting each other as much. Minor iterations ar quicker. Plus, it builds team spirit when everyone shares the same functional goals.

- Schedule a short review with the entire team on a daily basis. Divide it up into a design review and a product review. [N.B. This is not the same thing as the daily standup!] Do this review in the afternoon, around 2 or 3 p.m. By then, substantial progress will have been made before the review takes place, and there will still be room for team members to iterate afterwards. (More about reviews in Chapter 5.)
- After a week or two, take another look at the ratio of designers and developers. Change the team as little as possible. If you do need to make changes, do so for the entire sprint.
- Be critical with regard to team members. Not everyone is cut out to take part in an überScrum. Having to substitute a player is of course a pity, but not a crime.
- Don't be afraid to allow your design capacity to be flexible. It's fine for a designer to spend a day working on another project if necessary, as long as it's done in the team room.
- Scrum also has the advantage of greater "bandwidth" between the client and developers. As a designer, don't go back to your old ways and set yourself up as a mediator between them. Act as a volt meter, not an ampere meter: let the client and developers discuss matters directly.

You don't have to start using a Definition of Ready right away. Introduce it whenever you think it will help the P.O. or the team.

Did your überScrum get out of hand? Don't panic. You can go back to staggered sprints. Some teams even use a hybrid approach, making interaction design sketches at the end of a sprint for the next sprint. This can be extremely beneficial for sprint planning. *Inspect and adapt*—and try again.

6.2 Advanced deliverables

Definition of Ready

A somewhat advanced technique to assure that stories have the quality you need, even before sprinting, is to create a Definition of Ready (DoR) for the stories. A DoR helps to put the PO in the driver's seat and keeps them there—because *only* the PO must assure that the relevant stories in the product backlog are ready for the next sprint planning.

A DoR, like a Definition of Done, posits a number of requirements:

◆ The story is INVEST (see page 60).
◆ The story is written in a form decided on by the team (see page 59).
◆ The story has been preliminarily estimated by the team in a grooming session (see page 99).
◆ The story has been prioritized on the product backlog

We have found that you can also add helpful nice-to-haves or reminders to the list, for example:

◆ There is a business case for this story
◆ There is a high level interaction design, such as a flow or sketch, for this story
◆ We have a rough idea of how to build it
◆ We have an idea of the impact on the client organization

Code of conduct

We know that it is difficult to code properly and to test decently. The pressure the team experiences during Scrum might discourage developers from really taking their time and maintaining their motivation. We have seen the best of our senior developers go "quick and dirty" just to get stories finished—with minimal compliance with the Definition of Done. What with the PO pressing for scope, the art director pushing elements to their last pixel, editors complaining that the CMS's multiple file upload seems buggy, it is hard. Honestly.

Therefore we use a Code of Conduct. This can include whatever rules your team may decide are necessary to stay focused on delivering high quality. For example:

◆ Don't review your own code.
◆ Reserve Friday mornings for code refactoring.
◆ Create a UML diagram after each sprint planning.
◆ Do unit tests on crucial elements.
◆ Use abstract classes
◆ Report major changes to the development lead after each sprint.

And, of course, put it up on the wall. (Many thanks to the Allerhande team for these examples.)

Code of Conduct

Ander
reviewt
code

Code
Confensie

Elke 2e
Vrijdag van
Sprint een
refactorronde

UML
diagram
na sprint-
Planning

Pseudocode
op iedere
Code
↳ format

unittest
cruciale
functies > > Boolea
- etc

"Lange termijn"
Abstracte
Classes

Direct
documentatie
van nieuwe
functionaliteit

Python /
Django
unittests

Na elke sprint
korte samenv.
van wijzigingen
naar Paul v/d L

Filter Videos
Index
Command

Filter Archive
Index
Command

6.3 Quality is flexible, honest!

A good agency never disputes quality. They would rather say that the scope or the budget can be flexible—but quality must always be top-notch.

It's amazing how many people just go along with this. But no matter how good a product is, there is always room for improvement, which proves the statement wrong.

Every enthusiastic expert knows the feeling of wanting to make something better—more attractive, more complete, more useful, more slick—when there's actually no more room for this in the project. At this point in a waterfall project, you would probably already be over budget. The stressed out project manager would be trying to minimize the damage—and we'd be grumbling that the account manager undersold the project.

It doesn't have to be like this—so stop whining! A perfect product is unaffordable. Scrum is aware of this. One of Scrum's hardest lessons is that quality must be flexible. The burndown chart is inexorable; you don't get any extra Scrum days. Each day you must decide: What shall I do now, and what shall I do next time, or not at all?

"Good enough" is not a dirty word. You must ask yourself what good enough means. The answer might be "terribly, exceptionally good". We have not forgotten the advice in Seth Godin's book, *The Purple Cow*: "Today, the one sure way to fail is to be boring. Your one chance for success is to be remarkable." While this might make your product more elaborate or expensive, this is not necessarily a problem, as long as it's worth it. But don't think that only perfection is "good enough". Perfection is unaffordable and, more importantly, unrealistic.

Make your quest be for the Minimal Viable Product (MVP). Pluck up the courage to say that "better" is the enemy of "done". A great deal of skill is required to embrace this principle and still deliver quality.

6.4 Maintaining creativity

Scrum is not driven by creativity or quality. It is driven by progress—and whoever's driven by progress may be liable to cut corners. We have already seen how the Definition of Done is an important cornerstone for upholding quality in Scrum, but it can't guarantee creativity.

A great deal is known about improving creativity, just not within a Scrum context. In our experience there is a strong link between creativity and divergent or lateral thinking. This way of thinking requires, quite literally, time and space.

luckily this can be arranged. Here are a few suitable moments:

- During Sprint 0 you can plan all the activities you will do to give your project a conceptually creative start. Research, brainstorming, sketching, and letting simmer, mind maps. With a bit of luck you'll generate more ideas and concepts than could ever fit into the product backlog.
- You may also opt to carry out a style study in Sprint 0. Explore different visual styles with the client, and choose one before the real sprinting begins.
- Later on in the project, during the sprint planning, a story may reveal that you have grounds for going off the beaten track. Instead of taking the usual route, make allowances for this. Weigh up the contingencies: to what extent might this branch out? In your story, for example, you might incorporate a brainstorm as a task. Have the team determine what the budget would be to get this story done.
- Creativity requires energy and optimism. Encourage the team's energy and optimism, and every sprint day will provide room for new flashes of creativity—thus giving your product that extra edge!

Good ideas do not always crop up at the best of times. This is why we make sure that every Scrum room has a place to display these spontaneously arising ideas. Then the Scrum Master and PO can always see which good ideas have arisen that have not been incorporated into the project. They can decide which ones to reject, which ones to address in upcoming sprints, and which ideas will be used to reprioritize the stories of a sprint currently in progress.

6.5 Integrating user-centered design (UCD)

For some reason, many people believe that Scrum entails never leaving the team room and being glued to your computer screen. (Some may even think the team room is out of bounds for non-members.)

But in Scrum you can make room for everything you and the PO deem to be important —including user centered design.

Let's just imagine we want to make room for three forms of UCD:

- User research in preparation for design —For example, field studies, interviews, card sorting and participatory design sessions. Sprint 0 is the best time for this, because this research will influence product size and contents. This—in the form of a product backlog —is precisely what you want to broadly establish in Sprint 0.

125

- Paper prototyping and working product usability tests.
 As soon as you have your initial designs or the first components of a working product, you want to show them to people—colleagues, passers-by, friends or family—to see if they work. With Scrum you don't have to drop this habit; it's an informative testing method. Be sure to incorporate it into your stories in the form of tasks.
- Scripted lab usability test. When the product has become reasonably usable, it's time to test it in more depth. In our experience, this should occur once in every two sprints. You can test it in-house (Steve Krug has written a useful book on this: *Rocket Surgery Made Easy*). Or you can outsource it to a specialised lab. Decide beforehand whether or not to put your sprint on hold for a few days during the test.
 Like all committed specialists, research agencies like plenty of lead-time to carry out their work. We find that it helps to have them submit a report within a day or two. Some offer weekend service, so you can get the new insights by Monday morning. Others are willing to come by at the end of the day or the test, to discuss the main findings and measures in person. Sometimes it's actually not a bad thing for the team to have a week's break from the project.

Here's a bonus idea: Set up the sprint demo as a usability test. Have a working script at the ready, and ask all of the invited stakeholders to use the product. Although as testers, they're not really representative, this is a very instructive experience for everyone! (More about this in Chapter 5.)

6.6 Documentation

"Eliminate waste" is the first principle of Lean software development, and Scrum has borrowed many of its principles. But is documentation "waste"? Sometimes it is, but not always. Ask yourself what the purpose of the documentation is, and take a different approach to each type. For example:

1. Documentation used to establish project preparation, such as a program of requirements, negotiated business rules, sitemap. You must be very careful with these documents. They are typical waterfall documents. A sitemap is only useful if you're prepared to adjust it as more insight is gained. But you needn't set up detailed PoRs, and so on. Such documents are rarely accurate for any length of time and before you know it, they'll just be gathering dust. It is the PO's presence that guarantees a project's proper scope. While waterfall requires set goals, Scrum just requires a set vision.

127

2. Documentation used to guide development on a continuous basis, such as brand values, user insights, a product statement, coding guidelines—this is what you need. Use PowerPoint style not reams of text, so it can be displayed on the wall and seen from a distance. Remember, nobody will look at documentation that's put into a folder on a server. Waste of energy!

3. Documentation used to transfer knowledge between various disciplines —flows, wireframes, and PoRs—are rarely needed when team members work together in the same room. Usually a simple sketch or a quick one on one is all it takes to run through a story. We believe that only very complex functions or interactions need to be specified and worked out on a computer.

4. Documentation for comprehending the project at a later stage—such as an editorial guide for when the project has gone live, a corporate identity manual, a description of important technical preferences. This kind of documentation is essential. It is an intrinsic part of your product, and therefore its usability must be taken into account. Think carefully about who will ultimately use the outcome of the project. What will they want to know? Evaluate when this documentation will be needed. Ensure that it's succinct and addresses any issues that may come up. Provide something tangible— not just an email with attachments.

Documentation is a deliverable, like everything else. You create it doing tasks within existing stories. Or you can create dedicated documentation stories. In practice, for types 1, 2, and 4 (see above), we usually opt for the latter: separate stories with your own priorities and planning. Only the third type of documentation (transfer between disciplines), involves tasks within existing user stories.

6.7 Dealing with clients

With Scrum you, as the agency or design & development team, invite the client into your territory. You will be exposing many different facets of yourself. Look on it as also selling an experience. The Scrum room and the environment must be up to scratch. This doesn't mean that as an agency or team member, you cannot be yourself. Scrum is not an ongoing "presentation". Showing some emotion is no problem, and we all get tired once in a while. Do, however make sure that everyone is punctual at all times. Otherwise, just make sure there is enough alternation between busy periods and slumps. Is there a Dubstep Friday? Someone wakeboarding the rug? Or primal chest-beatings to mark little victories? Anything goes. Scrum is never boring!

Nevertheless, working together is not just about your own conduct. You will be giving the client, as the PO, a significant amount

f control and work together several days
week. This means you will certainly get
know what that person is like! Spot the
lients listed below in their natural habitat:

he opportunist
he PO is not always the person in charge
f the budget. It is important to identify the
ynamics arising from this fact early on.
ome POs take advantage of extra sprints
nd tests without allocating the required
udget. This will lead to problems later on.
lake sure you know what the budgetary
mit is.

he hypercritic
ome POs take advantage of their influence
y taking a highly critical stance. It is impor-
ant to make them see the consequences
f this straightaway. The burndown chart
ill go down less rapidly; the team's speed
ill also plummet—and this will affect the
roject's scope. It is enormously helpful to
oint this out to the PO before the start of
he project.

he worrier
nd then there are the POs who find it
ifficult to take the plunge. They must con-
tantly check everything with their stake-
olders—at the expense of the project's
manoeuvrability. What this means is that
many stories are left unfinished, awaiting
eedback, which leads to costly reworking.
f discussing this issue doesn't help, switch
o staggered sprints.

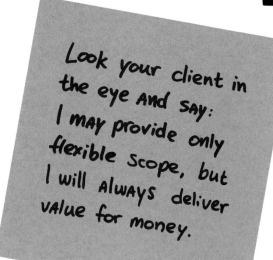

Look your client in the eye and say: I may provide only flexible scope, but I will always deliver value for money.

129

The meddler
Some POs are so sociable and interested in
what's going on, they'd like nothing bet-
ter than to look over your shoulder all day
long. Do explain that you would be more
than happy to give additional explanations
and details about your work in the design
review—but that in order to deliver qual-
ity and speed, concentration is required.
POs should also be reminded of their own
duties. If none of this works, you could scale
back the PO's team presence to a minimum
of 2 half-days per week.

6.8 Dealing with the agency

Along with the Scrum Master, the client/PO has a high level of responsibility for driving the team. And although your and the agency's interests are generally the same, you may still run into situations that make you question whether you, the PO, are doing things as best you can.

Scope soufflé
When a Scrum project isn't running smoothly, the burndown chart doesn't go down fast enough. The team doesn't reach the estimated velocity, and then adjusts the sprint goals to make the number of stories fit. The result: the product scope rapidly decreases. This can happen all too easily. So ensure that the team works together efficiently, that your choices are made intelligently, and that your energy is put into the things that you and the Scrum Master consider to be most important. (More about Scrum troubleshooting in the next chapter.)

The merry-go-round steering wheel
Do you remember how your steering wheel worked on the merry-go-round? You could turn it all you liked, but the merry-go-round only went in one direction (usually left). Make sure the Scrum Master provides you with a proper steering wheel. You are the one in charge of the product backlog. Nobody else. The team can, of course, advise you in making choices—but you are not called the Product Owner for nothing.

Team frustration
Scrum requires a different senior/junior staff distribution than some organizations are used to. It won't do to have junior staff members working on "the job" all day, with a senior staff member only shadowing them for half an hour. You may note that junior team members are not full-fledged discussion partners (through no fault of their own). They may have trouble comprehending or retaining your input, or formulating well founded counter-arguments. Discuss this if necessary—but be sure to have enough senior staff members around.

By Pieter Jongerius

131

By Jeroen van Geel

7

Trouble shooting

135

Scrum is like a dream. Everyone goes about their work with a smile on their face. Developers and designers always fully understand each another and never keep each other waiting. Projects are always within budget, and customers give a round of applause at the end…

Well, this is how we like to imagine it! But unfortunately it's not always the case. A good Scrum project depends on many different factors. In this chapter we discuss some situations that may arise, along with our advice.

7.1 People

How to deal with team members who have little or no Scrum experience?

Virtually every project includes people who have never been involved in a Scrum project before. They could be customers, people from other companies or your own colleagues. How should you deal with them?

Solution: It goes without saying that your office should endeavour to allocate as many experienced people to the job as possible. But if this is not feasible, it needn't be a problem—as long as certain other things are done properly. For example, be sure you give a clear presentation of the Scrum process to future team members and stakeholders at the start of every project. Speak with the PO in advance and run through the process together. At Fabrique, we have a presentation kit that explains our Scrum principles, and we always recommend that our team members read the book. Don't let them get bogged down in theory but let them rapidly put things into practice. The best way to get a grip on Scrum is to actually do it.

What about team members who think Scrum is silly?

There are of course people who don't like Scrum and would rather stay well away from it. Nevertheless, they occasionally end up on a Scrum team. How should you deal with this?

Solution: Don't start making special allowances. If one or two team members don't like the daily standup, do not drop or shorten it—or allow them to miss it. A Scrum project will only be successful if the basic process remains intact. So what *should* you do? Have a chat with these team members, and let them explain their aversion to Scrum. In doing so, don't jump to conclusions; be sure to get all the details. Only then will you be able to come up with good solutions. Resistance often stems from a past Scrum experience, and too many lengthy discussions in particular.

What if frustrations arise within a team?

Every now and then, mutual frustrations arise within a team. There are many reasons for this, which is why there is no one

By Jeroen van Geel

solution—apart from this:

Solution: Ensure that these frustrations are discussed openly and constructively. Avoid the syndrome of complaining about each other around the coffee machine. Scrum is an open process. By discussing it openly, team members have the opportunity to improve their working method and to support one another.

How about team members who don't do good work?

Scrum is a team process. Because you spend a lot of time together, you get to know one another and it becomes very apparent what each team member contributes. The brilliant people stand out; weak members of the team also become apparent. It can be very frustrating for a team when someone contributes too little or doesn't make enough progress. In this kind of situation, you must take matters in hand.

Solution: Be sure to discuss everything openly. Walk up to the person in question and ask how things are going. Discuss the tasks that they've taken on and how they are coming along. In order to support this person, try to establish connections with other team members as well. Often the problem is that someone is just afraid to say they don't understand something. So they just continue to muddle along.

If this approach doesn't work, you could openly address the issue at a standup. When it comes round to the team member in question, focus a bit more on his or her tasks and ask why progress isn't being made. Ask the team to share their thoughts about how to solve this issue.
If still no progress is made and there is danger of a team member holding up the whole team, it's up to the Scrum Master to take the plunge and replace that person once the sprint is over.

When the team is in a rut, then what?

Have you been Scrumming for months and is the team getting tired? And even a week off doesn't help? This is known as "Scrum fatigue".

Solution: It is time to start rotating. Ensure that up to one third (maximum) of your team is replaced, and swap people around every three sprints.

[N.B. Never replace all team members who have the same skills at the same time.]

7.2 Process

Team members find the tasks on the wall unclear. How can I prevent this?

Solution: Have people hang the tasks up on the Scrum board together. Ensure that they write up their tasks in a way that is clear to all, not just the authors. Keep the tasks small; they are easier to define. If this doesn't solve the problem, review all the tasks with the team. Make sure everyone stays sharp and collectively takes responsibility for the quality of the tasks. This may take time, but it will result in things becoming much clearer.

When tasks take too long…

Solution: Ideally, tasks are small enough to move from "doing" to "done" in a day. If they take any longer it means they're too big. The whole team has to master this. It may feel like more work, but it actually provides a good overview.

What to do when the daily standup rarely happens within the desired amount of time?

Solution: Be strict. At a standup, team members may only talk about activities they have done or are going to do—and any contingencies. They can question one another about these matters, but any content-related discussion must take place outside the standup. It is no big deal to politely end any discussions about content; most people like it when a standup runs efficiently. By week's end, they will be used to the structure, and standups will be much shorter.

Quite depressingly, the burndown chart shows no sign of progress

Points are only subtracted from a story's total score once this story has been completed. The advantage of this is that the team is obliged to complete stories before they actually see progress. The disadvantage is that it can take a while for the burndown to go down.

Four solutions:

◆ Reduce the burndown with partial progress. This method entails running through the different stories at every daily standup. You and the team estimate the outstanding points per story, then add them up and feed them to the burndown chart. The advantage of this is that you can constantly keep track and discuss the progress of the stories in terms of content. The disadvantage is that, initially, team members' calcu-

BURNCHART SPRINT 4

lations are always optimistic, while the final points are much slower.

- Reduce stories by breaking them up. These smaller stories are finished sooner, and so the line goes down more rapidly.
- If your team runs into major impediments and very few stories can be completed, there is a problem in backlog grooming. Either preparation of stories is started too late or incomplete. More focus on grooming, or introducing a Definition of Ready might help.
- Sometimes the cause of a stagnant burndown chart is that stories are interdependent. They cannot be completed if they aren't all completed. Look at your backlog. Can you extract one or more underlying stories that have to be completed first, so that other stories can build on them? Can you define your stories more narrow, removing the elements that bind them together? In your efforts, remember that interdependency can never be prevented altogether.

Too many half-finished stories move up to the next sprint

It is not a problem to now and then move a half-finished story up to the next sprint. But it becomes tiresome if it's done too often, and to too many stories.

Two solutions:

- Your stories are probably too big. Take another look at the product backlog and break the stories up.
- Make the team start at the top of the Scrum wall and work their way down to the bottom. This may seem more time consuming, but stories must be completed. It's fine to work on two or three stories at once; any more than that just becomes inefficient.

Stories that were supposedly 'done' turn out not to be

Have you not managed to test a story? Is there still no real content in the CMS? Are there still some bugs that need to be fixed? Then your story isn't done. Your team is suffering from the lulled-to-sleep effect. The post-its are up and everything has moved up to *done*—but it isn't.

Solution: Take a good look at the Definition of Done. Do you need to expand it, or make it clearer or more visible? Give the team a pep talk about how things are only done when they've actually been finished.

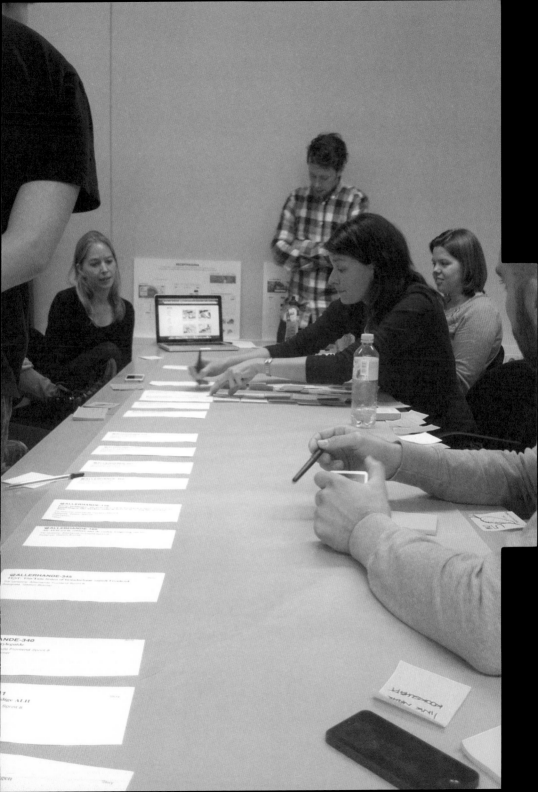

Should I call in extra people if we don't make a sprint?

Solution: No. Scaling up your manpower during a sprint may seem like a good idea at first, but it isn't. It will take your team a great deal of extra time to set new people to work, so ultimately you will gain very little time, if any. A better option is to evaluate between sprints and move or add team members then.

Should I extend a sprint if we don't reach our goal?

Solution: Yet again, no. Extending a sprint messes up your overall plan and gains you very little. It is best to end the sprint at the scheduled time. Give it a proper evaluation and incorporate the unfinished components into the next sprint. Instead of blindly moving on, let a fresh start provide a better overview.

7.3 Product

When the end results of our Scrum projects are only average, how do we produce something unique?

Every project runs the risk of producing an "average" end result. For Scrum projects this risk is enhanced. Clients are constantly looking over your shoulder, designers may spend less time working up different ideas, and there's a chance the team will settle for a compromise.

Solution: If you really want to accomplish something outstanding, you must ensure that there is a good basis. In Sprint 0, make sure you have a concise concept, with a sound structure. This will put you on the right track; you can do the fine-tuning during the Scrum journey. For more tips, read our section on Maintaining Creativity in the Sprinting Secrets chapter, page 114.

By Jeroen van Geel

143

8

Meet the team

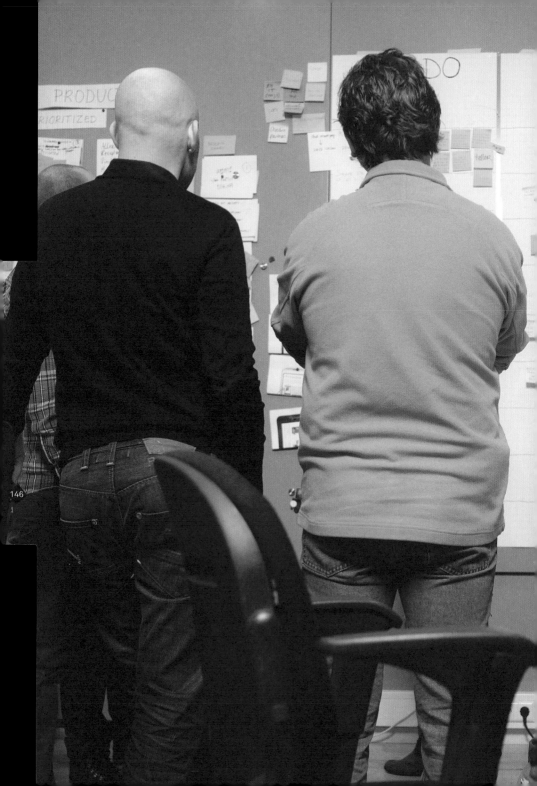

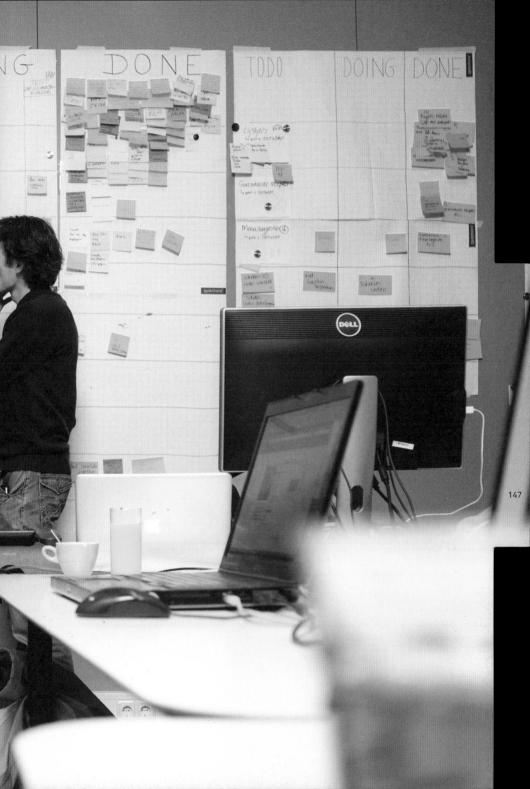

Scrum Master / Interaction designer

For a Scrum Master, the biggest challenge is striking a balance. On the one hand, I ensure that the team is happy and finds their work gratifying. And I act as a sort of 'shield' for the team. If the PO wants to go to them directly with various questions and requests, they must go through me first. On the other hand, of course, the POs want their money's worth. I help to ensure that they get it.

Patrick Sanwikarja

My role is that of a facilitator. I make sure the Scrum board is in order, and that the Planning Poker goes well. I push the team to do the daily stand up.

I love the fact that everyone sits together in the same room. This always enhances the quality. Another huge advantage is that things actually get finished. You don't submit a nice design, only to discover a very disappointing outcome at a later stage. In Scrum you're constantly involved and what you supply is exactly as you want it to be.

Team members must be willing to embrace the method and take matters in hand. Your team must have a good balance of senior and junior staff. It is also important that the PO is someone who has a good understanding of how Scrum works—and who can truly make decisions. At best, you establish a flow whereby the team is working together smoothly, and the PO is getting the quality she expects.

One of Scrum's most important principles is "Eliminate waste". For instance timeboxing, which lets you make sure that a sprint planning yields at least something to work with within three hours. Another example is the elimination of superfluous

design documentation. And the ultimate elimination of waste applies to the end product. What should or shouldn't I include in the product? A well focused product has only those features that are most relevant for the business and the users.

I think Scrumming will become more and more popular. On the other hand, there has also been a rise of "flex-work" and working from home. This is an interesting area of tension, as it clashes somewhat with Scrum. Scrum's added value is partly due to having everyone sit together. This is where much of the synergy lies. I would be very curious to see if it might be possible to Scrum remotely. I hope I get the chance to try this out one day.

Patrick Sanwikarja,
Scrum Master / Interaction designer

149

Watch the video
fabrique.nl/getagile/patrick

Scrum Master / Interaction director

The Scrum Master's main task is to get rid of any obstacles that the team might face. I ensure that the team can constantly move ahead with a project, and that nothing stands in the way of meeting the deadline. I look at how all team members are doing on a regular basis.

Jeroen van Geel

f any matters are unclear, I discuss them with the whole team. If one team member is frustrated with another, this must also be openly discussed and I have to clear things up. It's a bit like playing a game of curling, really!

One very important thing is having a tidy wall: making sure everything is in the right place, and getting people used to this practice. You should know where all the post-its go. They should be hung in neat rows—and be legible. I keep my team on their toes about this.

We no longer devise things that look amazing, only to find that there is a limited budget, leading to a slack end result. Customers also always want the earth. But with Scrum they are embedded in the team. This makes them see the limitations, as well as the possibilities and potential. You can then work to achieve the end result together, with much more understanding on all fronts.

You need a good team, people who are willing to go all out—and a customer who wants to be part of this. It is very tricky to Scrum with a customer who wants to stick to a traditional process, and know exactly what they'll get for their money. It implies they are still afraid of the process.

A Scrum deadline is not just a dot on the horizon. Deadlines are ongoing. This puts a lot of pressure on the Scrum Master, who must make the team aware of having to genuinely produce results on a daily basis. Some Scrum projects are still inclined to work like Waterfall, with everyone working away on a big and beautifully polished product. The beauty of Scrum is being able to say at any given time: "Guys, this is good enough. Let's move on to the next story."

Working in a flexible and iterative manner is becoming more and more important, as the projects we work on become more and more complex. With Scrum we can handle this. Scrum helps us to be closer to the customer and more on top of the process, which enables us to carry on developing. Another thing to consider is this: with websites and other digital products no longer being seen as end results, it's becoming increasingly important for development to be an ongoing process. What we are actually developing is services.

Jeroen van Geel, Scrum Master / Interaction director

Watch the video
fabrique.nl/getagile/jeroen

Product Owner

Albert Heijn relies on me to see that the right things are done, and that they are done properly. This means that I have a lot of dealings with the Albert Heijn people and the stakeholders, ranging from IT to web editors. As for the Scrum team, I'm the person who oversees the process and works with the Scrum Master to achieve the best possible results.

gaston brener

With business, design, and development all sitting together, you easily get an insight into things. You find out what direction you should be heading in; what is feasible; what is best for the customer. And you're in a good position to weigh these things up.

Results can be achieved and perused relatively quickly. Scrum has helped Albert Heijn to simplify large, complex projects. This doesn't mean that the Scrum approach is easier. But Scrum does make it easier for us to start a project and end up with the results we were looking for.

Clients unfamiliar with the process may find it unsettling that they have basically spent their money, while the Scrum scope is flexible. What I need from my stakeholders is trust and understanding. Understanding in terms of the Scrum process, and trust in terms of being able to make decisions independently. Scrum doesn't work if I must constantly liaise with the organisation. I also require trust from my team and I must provide them with energy and inspiration.

Scrum is practical. Previously, interaction design was completely worked out and detailed in advance, sometimes even like functional design. Now we provide sketches that go straight to visual design—where the same process actually applies. There is much more real-time project control than there is with milestone management.

The Scrum Master is the PO's partner in crime. The PO must organise the business side of things, and the Scrum Master does the same for the team. So there has to be a high level of trust and honesty between these two. I find this rather exciting—as is determining to what extent to involve the team. For example, it is perfectly acceptable to discuss with the team how the backlog is progressing; but not a good idea to discuss the steps that may be needed to improve the team's progress. You would then end up with too many opinions and attitudes. This is something you must sit down and decide on with the Scrum Master.

Albert Heijn first used Scrum on the Allerhande project in 2009, and it paid rich rewards. Scrum is now used for all large, complex web development projects. Albert Heijn is often a trendsetter and innovator. But too often we find that existing processes make it difficult to get these innovations into the market without delay. Now we can say that they must actually be tangible within, say, three months. Due to the complexity of the business process, I believe that many aspects of Scrum will be applied in other areas in the organisation.

Gaston Bremer, Product Owner at Albert Heijn

153

Watch the video
fabrique.nl/getagile/gaston

Strategist

Scrum is like a locomotive barreling down the track. Everyone is fully focused on the project and what needs to get done at that very moment, in that precise second. This means there may be a tendency to go for easy options. I help with the decision-making and make sure that the product vision is upheld. I keep everyone on their toes.

Anton Vanhoucke

In Scrum I'm much less involved with specifications, such as lists of criteria and reams of text prior to drawing up and building a site. I can now easily create a vision based on an outline. The details can be filled in along the way. This often leads to much better solutions. Why? Because you can always draw up a set of specifications in advance, but it's impossible to predict their outcome.

A team has to be close-knit. A certain bonding process has to take place. When you get to know and trust one another, the team will work like a well oiled machine. When the team is not really close-knit, when people just come and go, and when not everyone is present for the entire time, the momentum gets lost.

I don't scrum every single minute of the day; I do other things as well. There is always, of course, the danger that the team picks up so much speed that, at some point, it leaves you behind. So for me it is a delicate balance between keeping up with decisions and not spending my entire day on Scrum.

I hope that due to our good results, our customers' confidence in Scrum grows. Then we will be able to Scrum more often, and get to work with just a vision and a good backlog. Instead of having to generate full project specifications in the proposal stage, like we used to, we can get absolutely everything we need during the building phase.

Anton Vanhoucke, Strategist

Watch the video
fabrique.nl/getagile/anton

Interaction designer

As an interaction designer I do a lot of sketches with pen and paper. I also liaise with the visual designers, and especially with developers, to see if my ideas are actually feasible within the limits set in a sprint planning.

Anna Offermans

With Scrum things happen faster. You can never know exactly how something will turn out. You may have an idea in your head, but it only becomes a reality when you can actually see it. Scrum enables you to obtain a working prototype that people can contribute to straightaway. Combining the ideas offered by different people delivers the best results.

The danger is that due to time constraints you may be easily satisfied with a first draft that is almost good enough, but not outstanding. In Scrum, because you're always working on different bits and pieces, you risk losing sight of the bigger picture: all the different website paths. It is essential to make time for this from the very beginning, when you're still thinking things through. So this time must be factored in during a planning session.

On a regular basis, I will put an updated sitemap up on the wall. People can then see how the element they're working on fits into the bigger picture and what it relates to. It is important that these things become clear to the whole team, including the PO.

As interaction designer, I do feel I'm pivotal to the team. After all, the interaction designer is the first person to discuss specific matters with the PO—yet you also have dealings with everybody and genuinely work with one another, which is great.

I think we will all end up working in a more iterative manner. We can't keep documenting everything forever; things are changing too rapidly in this sector. It's impossible to predict what should be online six months from now. Working more closely with the customer to make a perfect product together is a step in the right direction."

Anna Offermans, Interaction designer

157

Watch the video
fabrique.nl/getagile/anna

Visual designer

As a designer you must already have an idea of the "look and feel", before you start scrumming with the whole team. This has to be tailored to the customer. You don't want to find out after the first demo that you're completely on the wrong track.

simone van Ryn

n Scrum, because you all sit together you can have a direct impact on how something s worked out. Without delay, I can show customers my ideas and ask them what they think. As a designer I can also think about interaction and work things out directly in that way. This is a big improvement on working in isolation.

Scrum is very timeboxed. Things must get done within a certain time frame. Some people find this annoying, but this is what I like about Scrum. It keeps you on your toes and on top of the priorities. If this is done properly, the crux of a product becomes very clear.

You need a team that communicates: people who are open, transparent, and who show you what they're doing and involve you in it. You, of course, must also involve others in your work. I feel that another important prerequisite is knowing you have the freedom to take time and explore— despite the fact you're time boxed and the timer is on.

In a traditional project you often go from home page to overview page to landing page. In Scrum you are much more involved with solving a particular problem, regardless of what page it relates to. What visual means do you need to obtain the best solution?

You are constantly building on what you did an hour ago. Sprint 0 is, in fact, my territory. I look at what kind of cosmos is being created there. Once we are actually in that cosmos, we will all decide together what direction to take. Then I am no longer in the driver's seat. I find this rather exciting. Where in your own cosmos will someone else take you?

Simone van Rijn, Visual designer

Watch the video
fabrique.nl/getagile/simone

Web developer

I take care of the technical side of things: the development. I ensure that the website works and runs smoothly, and that the site can be maintained with a CMS. And throughout the project, I make sure that the latest version is always up on the product server.

Mark Dibbets

Scrum has certainly made my work more enjoyable. It's great not being the last person in the chain. Due to our broad experience, we developers also have good ideas. In Scrum we can influence the whole process, and our role becomes more central. I can give the designers my input, so they can make the right choices—smart choices based on their options and challenges. This way developers also influence the design process.

In order to do the work properly, a clear product backlog is essential. This means having a clear list that you can get down to work with. Large or vague components won't help the momentum. In this regard, Scrum, is no different than any traditional project.

People often wonder if designing and developing at the same time doesn't end up requiring a lot of "rework". Well, I think reworking can be a good thing: a kind of prototyping that lets you know if something works or not early on. It gives you the upper hand. For instance, in Waterfall if you realize at the last minute that something doesn't work, you have to start the exercise all over again. In Scrum, rework is a healthy part of the process as a whole.

Moreover I don't have to worry about process documentation anymore. Nobody would use it; it's a waste of time. In Scrum when something works, it's signed off. You don't have to provide proper external documentation until the very end.

As far as I am concerned, we should be Scrumming on every project that has any degree of complexity. I'm also fine with this taking place on site. Then you can take in more of a company's ambiance. I can just imagine the Scrum "A team" going on location in the Scrum bus and getting the job done!

Mark Dibbets, Web developer

161

Watch the video
fabrique.nl/getagile/mark

Project manager

My job has become easier thanks to Scrum, because the Scrum Master does much of the project manager's daily work. I can stand on the sidelines, stepping in now and then to support the Scrum Master.

Laura Klaassen

But now I'm mainly involved in scheduling the team, and monitoring all activities for the PO on a weekly basis, by providing summaries of the hours worked.

In Scrum, the danger lies in the preparation phase. If the customer doesn't really know what Scrumming is and how much effort it takes, problems will arise in the sprints. And if the PO isn't fully mandated to make decisions, their consultations with colleagues become a very important part of the picture. Otherwise much of what you do will end up having to be redone.

In my job, the emphasis is on the preliminary journey. By the time things are up and running in Sprint 1, everything should be in order. I manage the people, the teams, and the customer's expectations. But I no longer have to deal with extensive proposals. Proposals are much shorter now, because there's not really much to say about what the customer will get. This only comes to light during the sprints.

If someone falls behind during a sprint, it is up to me to find a helper or a replacement. If the customer can't keep up, I will try to help them as best I can, so they have time to deal with what's most important. In that case, I act as a kind of backup.

I'm very passionate about Scrum. I love the team-forming element. The team is more close-knit than it is in waterfall. And the customer is also really involved, which has huge advantages. For one thing, the customer can clearly see that everyone is working very hard. In this way, things are achieved together.

Laura Klaassen, Project manager

163

Watch the video
fabrique.nl/getagile/laura

Glossary

Scrum, from Agile to Waterfall

Agile – A rapid and flexible way of working. It originated as a software development method in the 70s. Scrum is an agile method, but Agile is not always Scrum. (p. 18)

Backlog grooming – To update the product backlog on a regular basis. Goal: to maintain an overview and have enough stories ready for the next sprint. (p. 99)

Burn down chart – A transparent chart which unambiguously shows the progress being made. In an ideal scenario there will be a dead straight line leading to the sprint goal, but usually the chart will start off almost horizontally and then bend down sharply. (p. 78)

Chickens – They are in fact people, who are involved remotely, or who have an interest in the project or product. As opposed to the pigs, they fly in and out of the Scrum room, and crawl under the fence. (p. 44)

Code of conduct – A set of rules put together by the developers. A work method which enhances the quality of their code. (p. 120)

Daily review – Taking a look once or twice a day at what we have done so far. Are you on the right track? If so, carry on. If not, go back a step. (p. 96)

Daily standup – A meeting held every morning, lasting 15-20 minutes and done standing up. What did you do yesterday? What are you going to do today? You'll soon be wide awake, especially if you have a cup of tea or coffee at the same time. (p. 95)

Definition of Done (DoD) – When is something 'done'? Or good enough? The Definition of Done gives a firm but fair indication of whether or not you can proceed.(p. 64)

Definition of ready (DoR) – A set of requirements and nice-to-haves which a story must fulfil in order for the product owner to include it in a sprint backlog. (p. 122)

Demo – The moment of truth at the end of each sprint. The team presents the outcome of weeks of intensive labour to the stakeholders. (p. 102)

Dubstep Friday – One day a week in honour of the Great Wobble. Some teams like to set a weekly theme day, good for building team spirit! (p. 128)

Epic – A story which is too epic to be realized in one sprint, or too vast to be properly defined as a user story. An epic is therefore usually broken up into different stories. (p. 82)

Flexible scope – With Scrum you don't know right from the start exactly what you're going to end up with. You get down to work but the end result is not something which has been explicitly set. The end result will always be a highly focused product but for the clients the initial uncertainty sometimes takes some getting used to. (p. 37)

eration – A sprint which is done when a product is being continuously developed. After each iteration a new version of the product is deployed. (p. 38)

igs – Team members who are an integral part of the Scrum team and scrum all day ong. They can't get through the Scrum room ence. (p. 44)

lanning poker – How long is each user story oughly going to take us? Everyone gives an stimate using a planning poker card. No, we on't just guess, we estimate! (p. 92)

roduct backlog – The complete list of tories you want to design and build. It's the ackbone of the project, and it's what carries verything else. The product owner owns the acklog and sorts it by priority. (p. 57)

roduct owner (PO) – The client's representtive in the team, and the actual owner of the product. It's all about mandate. Must be able o take decisions independently on behalf of ll of the stakeholders, or else no progress vill be made in the Scrum. (p. 41)

roduct statement – A concise, clear description of what you're actually producing, oreferably revealing the essential goal. For example: "The definitive manual for anyone who wants to use Scrum in design and development." (p. 52)

Retrospective – A brief moment of reflection, done with the whole team at the end of each sprint. What did we do right/wrong? In what way did the environment influence this? What have we learnt? (p. 107)

Scope – All of the functionality and content you create in the project. (p. 37)

Scrum – A method within the Agile framework. It originated in the 90s. It rocks. (p. 20)

Scrum board – A big wall covered with a large number of post-its. The full overview of the way things stand. What are we doing, what have we already done and what do we still want to do? And do we still have time for it? The answer is on the Scrum board. (p. 69)

Scrum Master – The team's servant leader. The person who ensures that everything runs smoothly. The anchor that provides support and thereby mediates, assists, monitors, leads, adjusts, speeds things up or slows things down. (p. 39)

Scrum room – The place where it all happens. It's always singular because we work as one team, in one room, on one goal. And we don't vacate the room until this goal has been reached. (p. 67)

Sprint – A defined block of several weeks during which we carry out part of the project. The whole Scrum is made up of a number of sprints. (p. 32)

Sprint 0 – A warm up before the first real sprint. A bit of a work out, a little stretching. What are you actually going to do? How are you going to do it? We decide on the strategy, the product statement, the amount of sprints and the product backlog. (p. 50)

Sprint backlog – The part of the product backlog which you take with you and implement in a certain sprint. (p. 88)

Sprint goal – The sprint's aim, drawn up by the team. It can express a certain feeling, a subjective value, or a knockout performance. As long as it excites people! (p. 65)

Sprint planning – A meeting held at the start of each sprint. The team examines the actual content of the stories in the sprint backlog and figures out what the related tasks are. The team also estimates how many stories they will be able to accomplish. (p. 88)

Sprint setup – The type and size of the sprints in a project, an early phase in the start up of a Scrum project. (p. 34)

Staggered sprints – A sprint setup whereby design is one sprint ahead of development. Orderly, but not as efficient as überScrum. Also known as WaterScrum. (p. 114)

Stakeholder – A project's interested party, usually from the client's side. A chicken. Someone who doesn't actually scrum,

but who is more than welcome to attend every Demo. (p. 41)

Story – See user story. (p. 59)

Story points – The team uses points to estimate story sizes. Why use points? If the team gets faster, they will discover that each sprint produces more story points. (p. 94)

Task – A small amount of work which is a logical story component. It can be carried out by one person, in one day. (p. 91)

Timebox – Set time allocated to an activity. In Scrum we don't like wasting time. We timebox everything. Period. (p. 20)

ÜberScrum – The Scrum of Scrums. The Holy Grail. UX design, visual design, content, front-end, back-end -you name it- are developed at the same time. (p. 116)

Unplanned items – Every task or activity the team thinks of that hasn't been thought of before but that probably must be done. The team puts these up on the wall in a in a cluster for the Scrum Master and PO to consider putting into the project. (p. 69)

User story – An identifiable, more or less separate unit which you are going to realize. For example: "As a reader I would like to be able to find all of Scrum's key concepts in one chapter." The whole collection of stories make up the product backlog. (p. 59)

Velocity – The team's speed, measured in story points per sprint. More experienced teams achieve a higher level of velocity. (p. 94)

Waste – Must be eliminated. Waste is found in discussion, documentation, the product, etc. Just go for what's essential. Keep it Agile, keep it Lean! (p. 19)

Waterfall – Old school method whereby each discipline gets down to work one by one. The opposite of agile. The visual designer waits for the interaction design, the developer waits for the visual design etc. (p. 18)